WATERCOLOUR
Practice and Progress

WATERCOLOUR
Practice and Progress

John Blockley

A & C Black · London

First published 1985 by A & C Black (Publishers) Ltd
35 Bedford Row, London WC1R 4JH
Reprinted 1987
© John Blockley 1985

Photographs on pages 29 and 47 by John Coles

ISBN 0-7136-2743-3

Blockley, John
 Watercolour practice and progress.
 1. Watercolor painting—Technique
 I. Title
 751.42'2 ND2420
 ISBN 0-7136-2743-3

Filmset by August Filmsetting, Haydock, St. Helens.
Printed in Hong Kong by Dai Nippon Printing Co. Ltd.

Contents

Acknowledgements

I would like to thank my editor, Judith Holden, for all her help and enthusiasm throughout the preparation of this book; Angie King, who designed the book, and Margaret, who produced order from my chaos of notes scribbled on scraps of paper and the backs of envelopes.

Foreword

This book is about watercolour painting with traditional translucent washes of colour. It is something of a personal project to restate and practise the basic techniques of watercolour painting, and to evaluate attitudes developed during many years of painting and teaching.

The book starts by defining and demonstrating the fundamental techniques – techniques that must and can be learned. Then, with a change of tempo, these techniques are used freely as 'doodles' and painting 'beginnings'. These are fun things to do and help to break down tensions, but also show practical possibilities and a foretaste of painterly thinking. The book develops to show ways of thinking and looking. The aim is to help break down fears of the medium, to help those starting with watercolour, and to expand the thinking and working of more experienced painters.

The paintings in this book derive from my interest in mountain and moorland landscapes and with places where land is deeply textured. Some of these places are remote, such as Sutherland in the top north west corner of Scotland.

Yorkshire, our largest county, is in the northern half of England and offers a variety of painting material. Wild moorland, hillside villages and an interesting coast with fishing villages cut into precipitous cliffs.

Much of my painting has been done in the north west tip of Wales, rugged mountainous country. Here, the architecture is simple and functional and on the mountains, derelict cottages are evidence of past isolated living. My painting *Derelict Cottage, North Wales* is typical.

This is ancient country, a Celtic land of folk-lore, myths and with its own melodious language. My grandfather precariously farmed a few acres in mid-Wales, and I remember cows being milked and the butter being churned. An uncle, I remember, from a small village beneath the mountain 'Snowdon' searched for words to tell me of things that could not be told with English words.

Pembrokeshire, in the south west tip of Wales, is magical and rich with evidence of pre-Christian life; standing stones and megaliths with the persistent aura of Druid and Celtic cultures. The land is full of intimate detail and sweeping views, such as my *Strumble Head* painting.

In contrast, the neighbouring industrial parts of South Wales offer a different interest, with smoke filled valleys and coal mines.

Lancashire, a northern county, has large areas of natural beauty and industry. Manchester is the major city, with nearby Salford uniquely captured by the artist L.S. Lowry.

The east coast of England is entirely different. Villages, such as Overy Staithe, sit in creeks, with mud flats and reeds brushed by the wind. The land is flat, giving emphasis to wonderful skies.

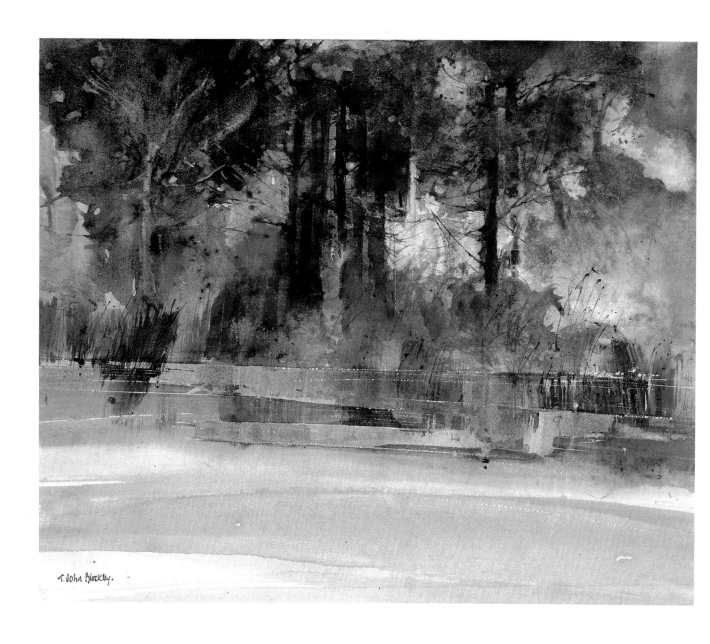

September trees

September is a time of flamboyant colour, with the risk of painting in garish colour. Here I aimed to suggest the ruddy colours and the florid decorative growth of branches and foliage, but I wanted them to be secondary to the main peep through of cool light between the trees.

The water is painted in flat planes of colour as a foil to the vertical tree trunks. The simplicity of the water also helps to stabilise the intricate movements in the trees.

Introduction

Painting with watercolour is a captivating experience. The liquid movement, the directness and immediacy of first-time colour washes belong uniquely to watercolour painting. It is fluid, of course—it runs, and no other medium is so mobile. These properties lead to its reputation of being difficult to work in, but this is a negative approach. The techniques of watercolour *can* be achieved with practice, and it will then be realised that the transparency and mobility of the medium are its main attractions. The process of manoeuvring liquid paint on paper will always delight.

Techniques of working with watercolour do demand a lot of practice. How much water to use, how to blend one wet colour into another successfully, judgement of drying times, the behaviour of different colours, how to judge and respond quickly when colours run, and whether to control or leave them alone: these are the mechanics of painting, learned only with time and effort.

The greatest difficulty is not in acquiring techniques, but in achieving new ways of looking and thinking. But this applies to any painting medium. In everyday life, objects are necessarily codified and labelled. They are isolated for purposes of identification: a jug is a jug, a house is a house. Inexperienced painters carry this way of separating and identifying objects into their painting, and strive to duplicate accurately and copy in everyday acceptable terms. Their main problem is in adjusting to a different, intensely visual way of looking, so that even ordinary familiar objects reflect a kind of magic. Painting is about freedom from everyday labels.

Freed from our conventional associations, we really begin to look and observe. We look for colour, shape, patterns, relationships of one 'thing' to another, and find the mood, the personality, the intrinsic value of things. We start to select, and paint those parts which interest us. Imagine, for example that you are describing a walk you have just taken to a friend: you want to convey the essence of the scene, and say 'the trees all joined together, red and green, one big colourful mass, like flames, flickering and dazzling.' Here, you are expressing an immediate personal reaction to what you have seen—you have selected from it what was most vivid and important to you. Painting is about making those kinds of connections.

The watercolour painter observes and thinks in terms of watercolour. He sees in terms of colour washes, colour blendings and senses the brush strokes and mentally paints as he sees. It becomes a way of life, a constant adventure and exploration. In this book I have tried to indicate some ways of expressing such thinking in terms of the traditional processes of watercolour painting.

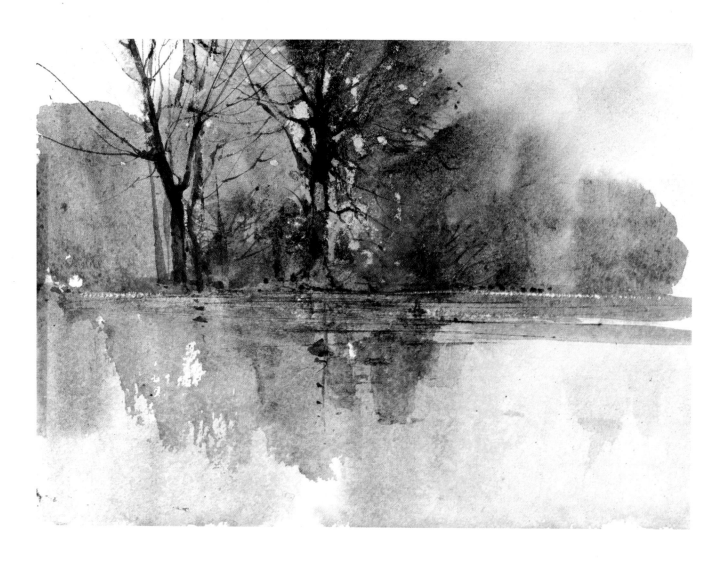

The sky and water were painted first with washes of translucent colour. The reflections were painted next, and, finally, the trees were added. This is the traditional way of working, starting with large washes over all the paper and then progressing towards detail.

PART 1 *Basic processes*

Watercolour washes

Watercolour painting is basically a process of making colour washes. The painter mixes paint with water and brushes it onto the paper to form a wash of colour. The liquidity of the medium provides the main characteristics of watercolour painting.

The first, rather obvious, point is that water is the vehicle for spreading the paint and allows the painter to cover large or small areas of paper quickly with thin films of translucent colour. He can also draw lines of colour and make various brush marks. These processes are the ingredients of watercolour painting. The use of water does not necessarily mean that watercolours are wishy-washy; we shall see that it is possible to mix rich dark colours that are still translucent.

This quality of translucency is the biggest factor in watercolour painting. Light is reflected from the white paper through the paint to give a luminosity that is unique to watercolour. We shall discover also that this translucency can be exploited by building up a painting with overlaid colour washes. It enables us to start a painting with a big wash of colour and then progressively build up with smaller washes. You will find that painting in this sequence of large to small washes is helpful in many ways. It helps to overcome the fear of the blank paper, and helps to establish the mood of the painting—we shall talk about this constantly throughout the book—and encourages a fluent approach rather than tentative niggling brush marks.

Materials

To start painting, I suggest you obtain only a few materials, and add to these as you gain experience. You will need paper, paint, brushes.

Paper

The paper surface and the thickness of the paper have a considerable influence on a wash. Basically there are three grades of paper:

ROUGH, where the surface is heavily textured and colour can be dragged over it to give broken, sparkling areas of colour

HOT PRESSED (H.P.) where the surface is very smooth and shiny—many painters find that wash control is difficult with this paper

NOT, meaning 'not hot pressed', which is sometimes called 'cold pressed'. I use this extensively. It has a discreetly textured surface, good to work on, and I recommend that you begin with this. The weight of the paper is also important. I normally use 140 lb (295 g.s.m.) which is sufficiently stiff not to buckle too much when wet. 140 lb means that a ream of paper (480 sheets) weighs 140 lb. It is useful to support the paper on a piece of hardboard, using spring clips to hold it in place.

Brushes

The best brushes are made of Kolinsky Sable, but they are expensive and the larger ones are difficult to obtain. Synthetic materials, such as nylon, are increasingly being used. I suggest three sizes of round brush to start with, a small one for detail, no. 4, and two larger ones, a no. 8 or 10, and a no. 12. Both $\frac{1}{2}$ inch wide, and $1\frac{1}{2}$ inch wide flat brushes are useful for laying big areas of colour.

Paint

Watercolour paints are obtainable in tubes or in pans. I use tubes because the paint stays moist and I squeeze out fresh amounts of paint at the start of every painting. My paint box has compartments into which I squeeze the paint and larger compartments for mixing washes. The disadvantage of moist tube paint is that contact with excess water, perhaps a too wet brush, will make it runny and uncontrollable. Pan colours stay compact and more controllable but require rather more effort in picking up a brush load of paint.

Many beginners start with an old box containing rows of pans, unused since school days or handed down from Aunt Maude. These boxes contain too many colours, all of them dried and cracked and usually one small splayed-out brush.

I recommend that, for a start, you buy a few tubes: aureolin yellow, raw sienna, burnt umber, alizarin crimson, pthalo blue, cadmium red. You can buy 'student's' or 'artist's' quality paint. I am sure that the artist's quality is more economical in the long run.

The painting shown opposite used only three of these, burnt umber, aureolin, pthalo blue. The greens and greys in it are mixtures of these. We shall be discussing colour mixing later.

Mixing a wash

Squeeze some paint on to the rim of a saucer—about enough to cover a thumbnail.

You will need some clean water—a jam jar will do. An egg cup of water will quickly get dirty. The jar I use holds about half a gallon and sometimes I use a bucket.

Put a small amount of water into another saucer. This is your mixing compartment. Dip the brush into the jar of water to almost the full depth of the bristles. Now give it a sharp shake to remove excess water so that the bristles are only moist. Then pick up some paint with the tip of the brush and touch this into the saucer of water and stir it—not too vigorously, but make sure that the pigment is thoroughly mixed and that particles of pigment are not left undissolved. These would make unwanted streaks of colour when the wash is applied. Now shake the brush again, or stroke it on a piece of rag, pick up more paint and add this to the saucer. Repeat this until you have a pool of colour in the saucer. Now stroke this onto any piece of white paper. This is merely a trial stroke to determine the strength of colour, before applying paint to proper watercolour paper.

Always follow this procedure of adding paint to a small amount of water, and progressively add a little more water if necessary to make a bigger wash. Never add the colour to a large amount of water—you could unnecessarily use up a lot of paint in achieving a strong enough wash.

The strength of the colour is largely governed by the amount of water used. More water makes a pale wash and less water makes a darker wash. You should experiment by making a number of trial brush strokes with varying strengths of colour mixings.

When you have finished painting always rinse the brush in clean water, shake out the surplus water, and smooth the brush to a point between your finger tips.

Applying the wash

Remember, this is the process on which all watercolour painting is based. We are going to mix paint with water and brush our paint mixture onto paper. It is a wonderfully satisfying process. I seem to spend most of my life carrying out this simple act and it is still a beguiling, capricious process, with the white paper offering so many possibilities. My own approach varies according to the painting I have in mind. A gentle landscape suggests gentle but firm brushstrokes. An exciting landscape invites vigorous brushstrokes. I have heard it said that all watercolour painting should be attacked and mastered. To me, this approach suggests insensitivity and lack of sympathy with the medium.

Now we can try some colour washes, about postcard size, on watercolour paper. It is useful to clip the paper to a piece of supporting hardboard. Rest the board on some books so that it slopes slightly towards you. Do not make the mistake made by many beginners of taping the edges of the dry paper to the board. If this is done the paper is restrained all round and will balloon in the middle when the wash is applied.

Flat wash

Pick up a brushload of colour from the saucer and brush it horizontally from left to right across the paper. Recharge the brush and brush another band of colour across the paper, below and slightly overlapping the first band. Repeat this process until you have a rectangle of colour. The idea is to try and obtain a wash of even colour. Repeat this exercise with various strengths of colour.

Some painters prefer to build up a dark wash by overpainting a series of washes. They say this gradual step by step process helps them judge the degree of dark. I belong to the other school, preferring the thrill of seeing a fully charged brush discharging rich colour onto the paper. A first time dark is both satisfying to do and more likely to give that limpid watercolour look.

When mixing a wash it should be made darker than appears necessary to allow for the fact that washes become lighter as they dry.

Example of flat wash

Example of darker flat wash

Overpainting to make a dark wash

Paint a pale wash and let it dry. The drying time depends on the wetness of the wash, the room temperature and the absorbency of the paper. When it is perfectly dry, paint a wash of the same strength (save some in the saucer) over the first wash, leaving a band uncovered at the bottom of the paper. Repeat the process until you have about four bands of colour, consisting of one, two, three and four layers. You can take this as the maximum number of overlaid washes possible without losing transparency, but even this depends, of course, on the strength of the washes. Be clear about this. I prefer to achieve depth of colour with first time washes wherever possible, but in practice the build-up of a painting does require some overpainting. The aim should be to make each wash with the minimum of brushwork so that the pigment is not stirred and muddied.

Overpainting—building up a landscape

The process of overpainting is often used to paint a landscape, or any other subject. The aim is to build up with thin washes of overlaid colour and then apply the final dark with one strong application.

Since the washes are translucent, it follows that a light wash cannot cover a dark wash effectively. The dark under-wash would predominate. This accounts for the traditional procedure of painting the lighter colours first and then successively building up with darker washes. We paint 'light to dark'. There is no such thing as white paint in this method of painting with 'pure' watercolours. If a white feature is needed, we leave white paper showing.

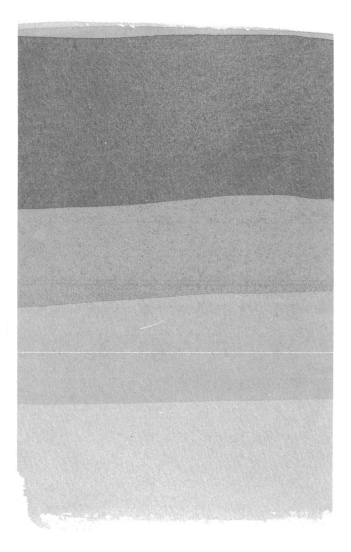

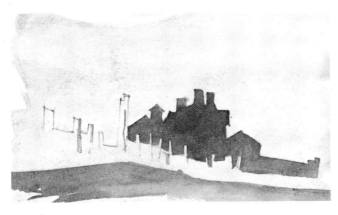

1 and 2

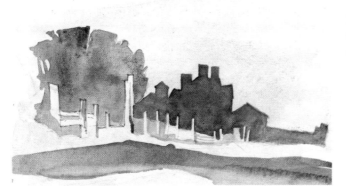

3

This painting was done in four precise washes:

1 A wash all over which becomes the sky and background.
2 A wash for the overall shape of the buildings, and the foreground shadow.
3 A wash for the trees.
4 A wash over the dark sides of the building. Notice that the first wash was left uncovered for the fence posts.

Each stage was allowed to dry before overpainting with the next wash. You can see that each flat wash builds up a hard-edged effect.

Throughout this book I reconstruct different stages of paintings. It is impossible to reproduce stages exactly in such a fluid medium as watercolour, but the reconstructions do give a general sense of the painting's build-up.

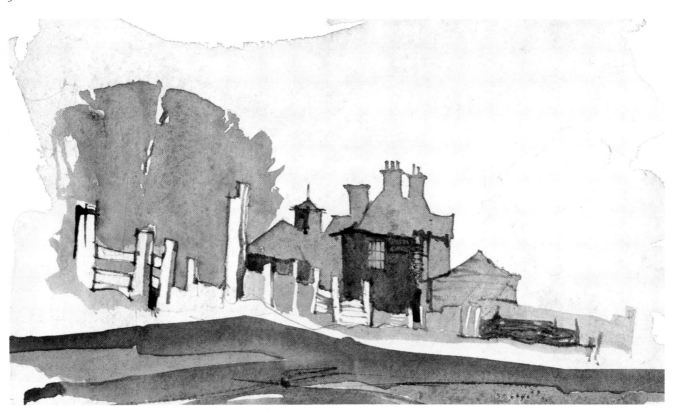

4

Graded wash

This is a variation on the flat wash. The idea is to paint a wash graded evenly from light to dark. Horizontal brush strokes of colour are made left to right as before, but at each stroke a little more colour is added to the water so that the wash on the paper gradates from light at the top to dark at the base. Alternatively, the first band of colour is made with a dark mixture, and a little water added to the mixture for each successive stroke. The wash will then be gradated from dark at the top to light at the bottom.

I have to say that I have never achieved perfection with these formal ways of working, but I am not particularly worried about this since I have never found it absolutely necessary to produce a perfectly graded or uniformly flat wash in a painting. Even so, they are useful exercises in learning to control the medium.

This little sketch of moonlight shows a simple application of a graded wash, with detail produced by lifting and adding colour while the graded wash is still just damp.

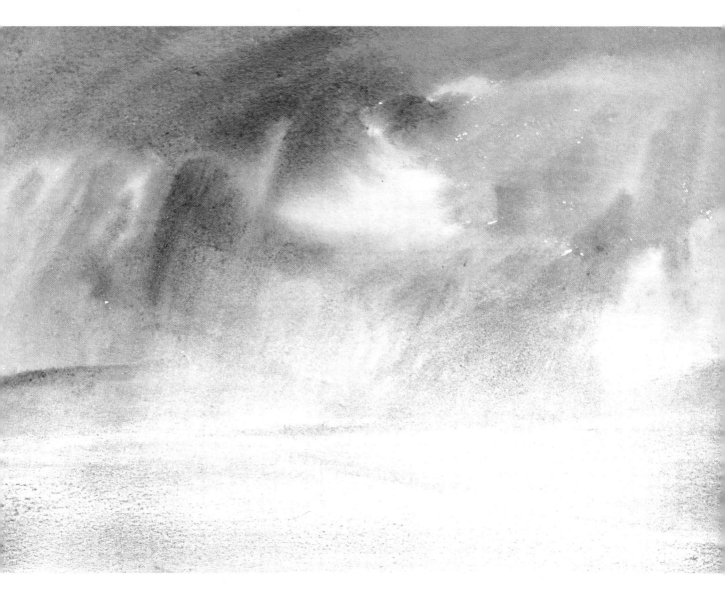

Dry or wet paper

So far we have talked only about painting on dry paper. Some painters dampen the paper first with clean water, before applying a wash. They say it helps in spreading the wash. My feelings are that the process can give an indefinable subtlety to the wash so I use it occasionally to suit a mood. In the main, I tend to think that I am more in command when dragging the colour over dry paper.

Here, I wet the paper all over and immediately added a little burnt umber to the wet surface at the bottom of the paper. This particular pigment will precipitate from a very wet wash, to give a speckled effect. This 'granulation', as it is called, can be increased by rocking the paper so that the watercolour mixture swills to and fro over the paper surface; we can see the effect again in the painting on p. 63.

When the shine began to disappear from the paper I brushed in the lighter tones of the sky, gradually using a stronger mixture for the darker tones with directional brush strokes to produce the form of the clouds. My interest was in creating a silvery light emphasised by dark clouds. I resisted the temptation to add definite detail.

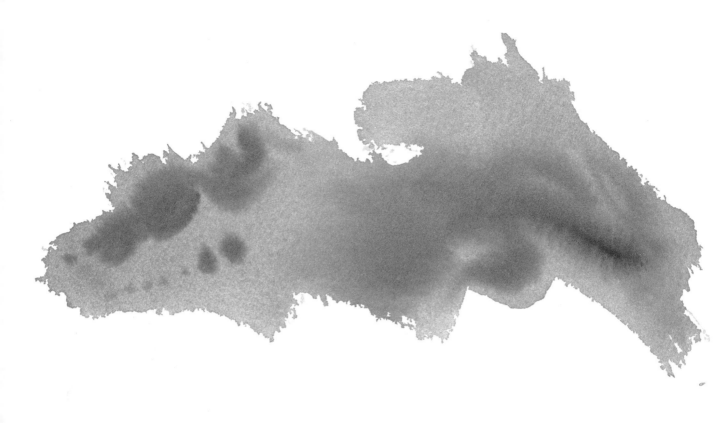

Wet in wet washes

Many painters like to paint with flat hard-edged washes, building up their paintings in the way we have discussed. Paintings done in this way can be delightful, with a feeling of clarity, and economy of statement. They require clear thinking, analysing the subject in terms of sequential flat colour washes. Other painters work for softer interpretations; colour is added to, or removed from, paint still wet on the paper. This technique is called wet in wet.

One of the delights (and anxieties) of watercolour painting lies in the anticipation of how one colour will diffuse into another. How this happens depends on the paper, the wetness of the mixtures, the air temperature, the dexterity and timing of the artist, and on the particular colours. Some colours tend to spread more quickly than others.

The figure above started with a randomly shaped wash of French ultramarine on dry paper. Into this I made brush strokes of darker mixes of the same colour. You will see that some brush strokes have spread further than others and their edges vary in softness. These differences were not accidental. They resulted from my judgement of the relative dampness or wetness between the wash and the brush strokes. You will be making such judgements, when you paint into a damp wash to obtain the softness of edge that you want for a particular purpose. Perhaps a shadow or a cloud, softer than its neighbour. From now on, you will be looking at everyday things, asking 'Is that edge softer or harder than that one?'

The relative wetness of the paper and the brush is quite critical. Subtle edges can only be obtained when brush and paper are moist rather than wet. Judging the degree of moistness will come with trial. Dampen a piece of paper with a brush, look sideways at the paper until the wet shine begins to dull, then just moisten some paint with the brush and stroke it firmly into the paper. Vary the dampness of brush and paper and vary the pressure on the brush. Vary the speed of the brushwork

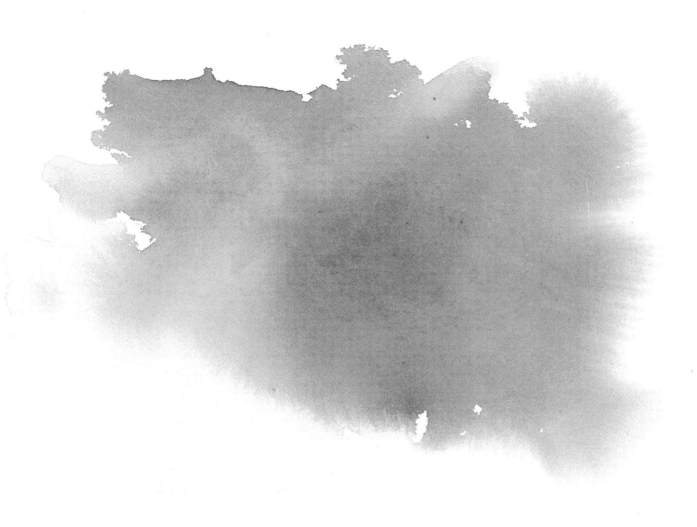

and try pressing the brush onto the paper without moving it. Once you have made these brush strokes, leave them alone, don't try to improve or correct them. This discipline produces clean, unworried colour.

The figure on the right shows an unsuccessful attempt. I worked into the first wash with a too wet brush and disturbed the pigment of the first drier wash and deposited it as an ugly stain. This is always likely to happen if a wetter brush contacts a drier wash.

Such stains are difficult to correct. They should be left, as an accidental imperfection in an otherwise perfect painting! Or, reject the painting!

The figure above shows a variation of the wet in wet process. Its purpose is to achieve an area of colour blending smoothly into a neighbouring area of colour. I painted a fairly wet wash of red (alizarin crimson) and immediately painted the yellow (aureolin) *alongside* and touching the red. They blended successfully without further brushwork, because they were of similar wetness.

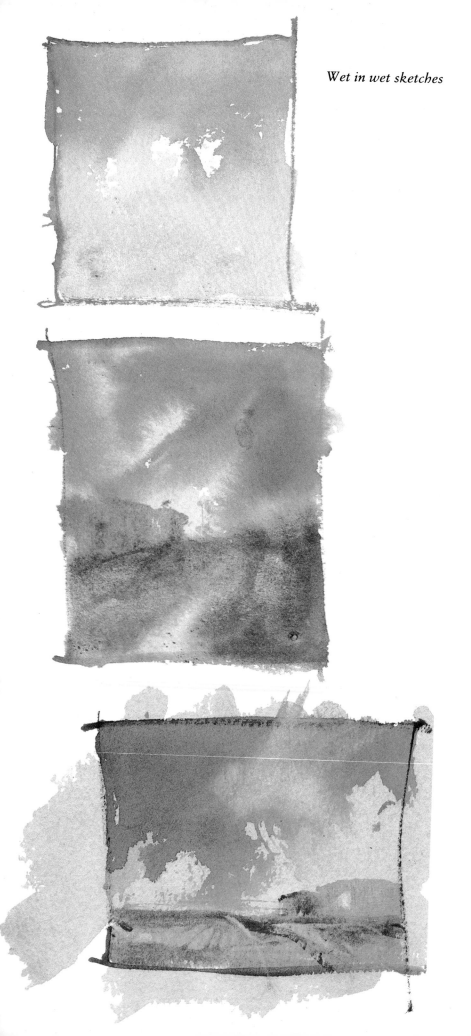

Wet in wet sketches

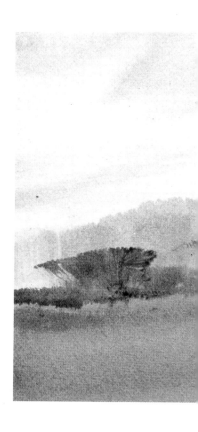

Application of wet in wet washes

This painting started with a wash of very pale colour all over, only just staining the paper, and worked into at various stages of drying to produce a variety of soft edges. The hint of cloud in the top left corner and the dark passages in the foreground melt into the first wash with very soft edges. The small groups of trees are all firmer, but are still relatively soft-edged. These edge values were obtained by waiting for the paper to dry a little and working into it with stiffer paint. The central group of trees was put in last. By this time the paper was nearly dry and so the tree group is comparatively hard-edged. I painted the shape of the group first and then drew the branches with a fine brush into the damp shape.

The painting is also concerned with the placing of colour and shapes. This is something we shall

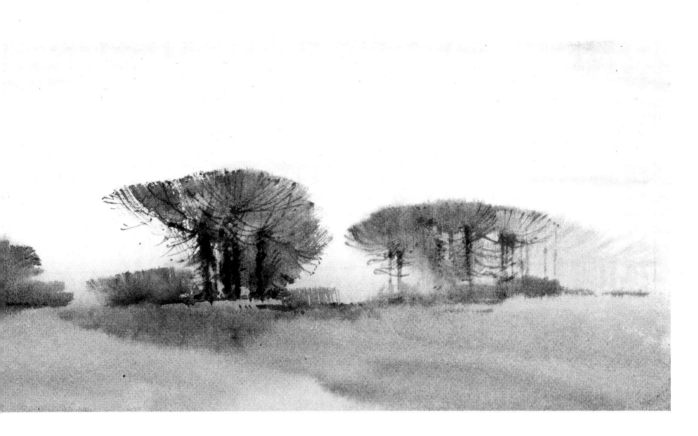

talk about a great deal throughout the book.

The sky and the smaller trees are various blues and blue-grey, the left-hand side of the foreground also contains a hint of blue-grey. The main group of trees is basically brown and connect with a brownish soft-edged blush of tone in the foreground. The important point is that the brown parts are collected and joined together and not scattered about the painting. This gives cohesion and helps to guide the viewer's eye smoothly over the painting.

Another point to notice is that the tree tops are similar in shape and even the cloud shapes loosely echo the curve of the tree tops. Echoing shapes and curves also help to hold a painting together. I am fairly pleased with this little sketch because of its distribution of hard and soft edges and the organisation of the various shapes.

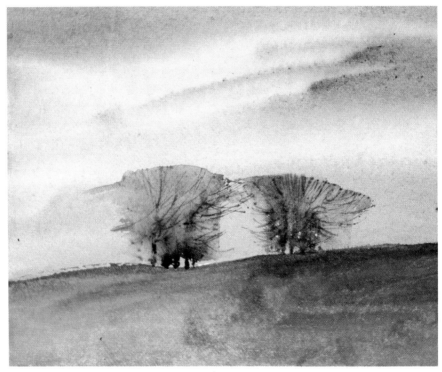

I enjoy making small watercolour studies, working mostly wet in wet with just a few carefully considered edges. This study also employs a number of echoing curves.

Lifting colour

When a colour is still damp on the paper, light passages can be absorbed from it with a clean damp brush. This is the reverse process of adding colour to a damp wash. Remember that the brush must not be wet or it will disturb the pigment of the wash.

The diagonal light passage was made by pressing a clean damp brush firmly on to the paper and stroking it across the band of colours. A damp brush was also used to remove colour from the edge of the colour band.

The sketch shown here started with a pale wash of indigo for the lightest part of the sky. A darker wash of indigo was brushed into this for the darker sky. The foreground is a wash of raw sienna allowed to touch and blend with the sky. The light passages in the foreground were lifted out by pressing a damp clean brush into the damp paint. The barn and the soft suggestions of bushes were added last.

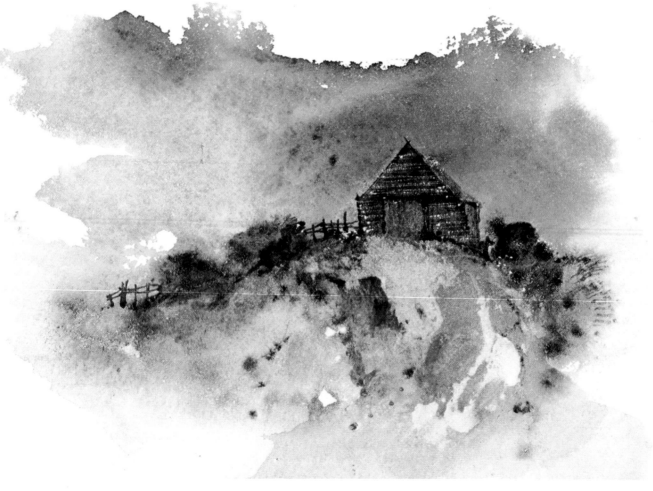

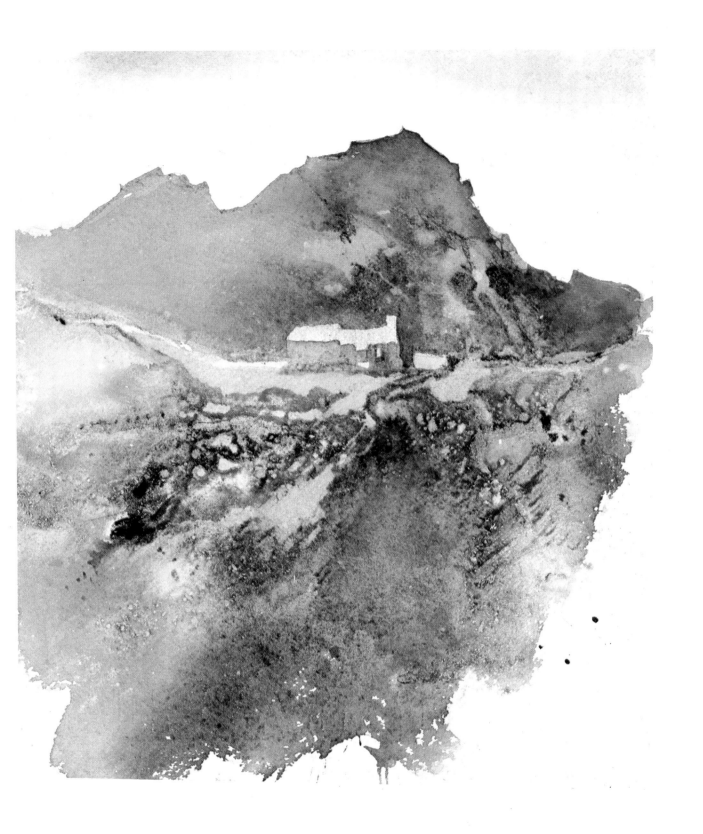

I wanted to show the mountain dark and hard-edged against the light sky and in contrast, the roof as pale and hard-edged against the dark mountain. To avoid a busy hard-edged effect all over I lifted the soft-edged textures in the mountain side and in the foreground.

Combining flat washes and wet in wet techniques

The paintings here show how the processes we have discussed can be combined.

In this painting I wanted to suggest a sense of space and distance by keeping it simple and relying on three washes, a dark foreground, contrasting with a pale flat wash for the distant hill, and an empty sky.

At first glance they are all flat hard-edged washes, but within each wash there are traces of wet in wet treatment, almost imperceptible but serving a purpose. More than half the painting is sky, but its apparent emptiness is relieved by the merest drift of wet in wet colour. The distant hill is ever so slightly darkened at its highest point. This often happens at the edge of a pale shape where it meets a larger, lighter shape.

The foreground contains soft brush work, just enough to suggest the ground contours without being fussy. The sky wash was painted over all the paper and allowed to dry. Then the hill wash was painted, also to the bottom of the paper, leaving a square of the first wash uncovered for the front of the building. This was left to dry and the dark foreground and the darks of the building painted in one wash. The hints of wet in wet paint were introduced at each stage.

Recall that in the sketch on p. 15 the first wash was left uncovered to represent the light fence posts. We shall repeatedly use this device of using a previous wash to represent a lighter feature.

Opposite: the sky was painted wet into wet to give soft clouds. The light parts in the foreground were lifted out with a moist brush. Finally, when the painting was dry, the hard-edged building and trees were added.

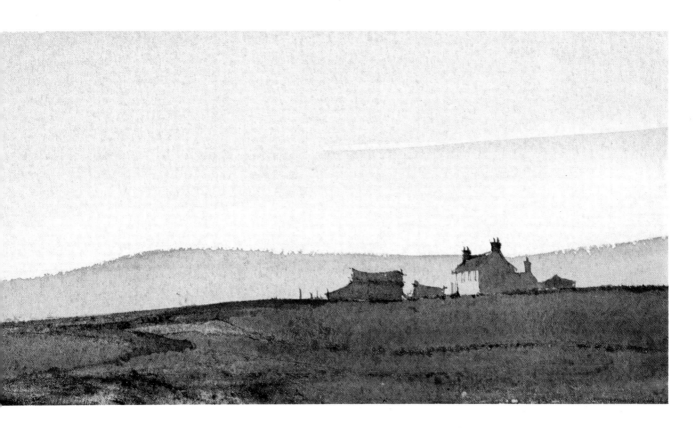

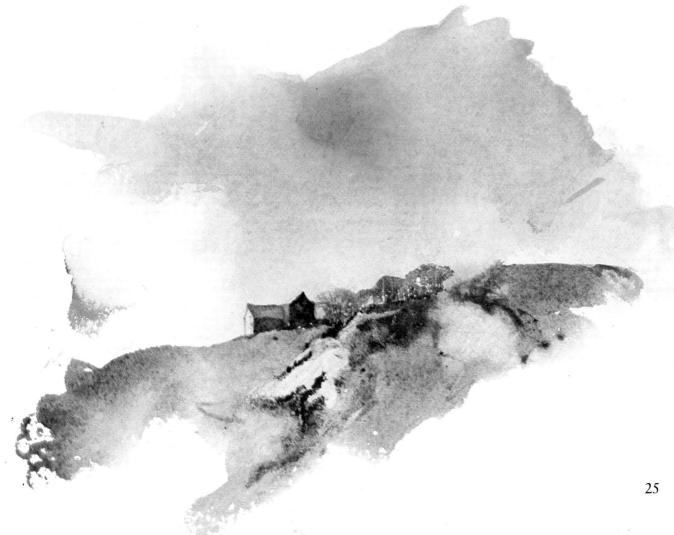

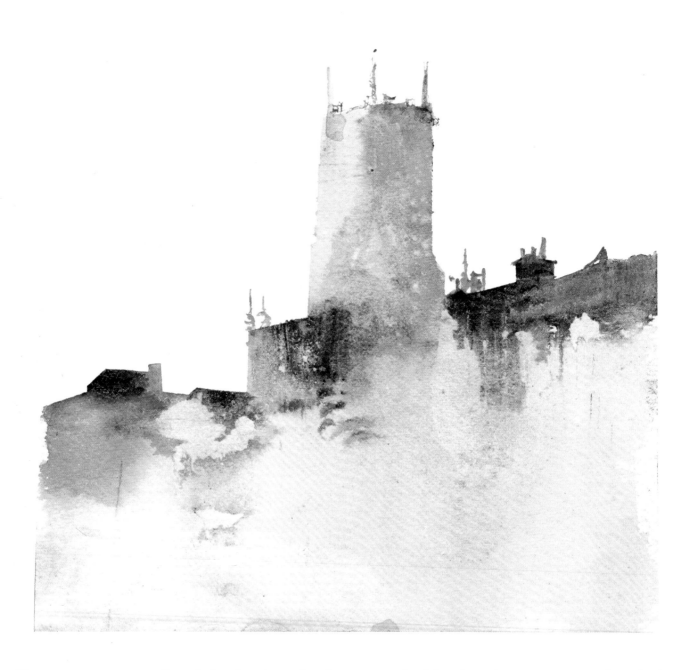

Here we see two stages of a painting showing a church which stands high above a busy market square and is flanked by rows of old buildings. It is a splendid example of ecclesiastical architecture in sculptured stone.

I have a liking for roof profiles. Here, I was attracted to the roofs, low on the left of the painting, and their 'ups and downs' gradually building up to the top of the tower, then dropping again to a roof level, not quite so low as that on the left.

Before starting to paint I worked out in my mind what I wanted to convey. I thought of this painting in terms of a mass of soft brush strokes, to contrast and emphasise the dark hard-edged roof line of the buildings. The church is also painted hard-edged, but deliberately paler to avoid having an over-emphatic, monotonous edge along the skyline. This is absolutely the message of the painting. I chose to draw attention to this feature and disciplined myself not to compete with this in the rest of the painting. As painters, we are able to make such selections and we must be able to choose, and to use the painting techniques we've learned to express our chosen idea.

26

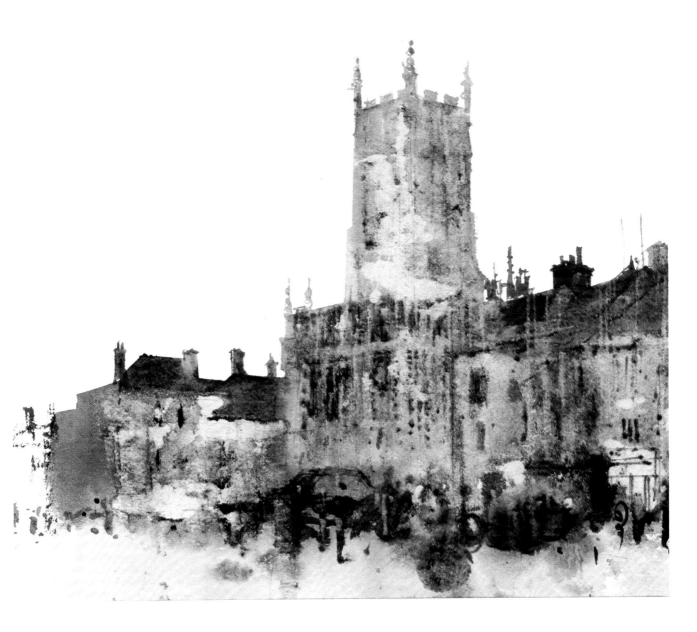

The painting began with a wash of raw sienna all over the area to be painted into, leaving the sky untouched. The wash was made on dry paper so that the buildings are hard-edged at the roof line. I waited until the wash was damp and painted Paynes grey into the roof on the left, a weaker mixture into the church tower, and burnt umber into the roof on the right. These colours have blended softly into the damp wash, but are hard-edged on the dry sky. To emphasise this crisp profile I suppressed my interest in the ornamental church details

and suggested them only with wet into wet brush strokes, dots, and by lifting colour in places with a damp brush.

Notice the differences in the lifted out parts. I have lifted the colour to recover almost white paper in the buildings on the left, so that it helps to emphasise the dark roof. Elsewhere the lifted out parts are less obvious, so that they don't compete with the light parts on the left.

Studio

My studio occupies two floors of a 16th century cottage. The ground floor is equipped with storage cupboards for paper and paintings and with one corner as a working place mainly for smallish watercolours. The photograph shows this, with an adjustable trestle easel, a table for paint box and paints, and a low table for reference materials.

Upstairs the roughly plastered walls are painted white and there is a big roof light. It is used mainly for large studio easel work, and larger watercolours.

It is very convenient to have such generous accommodation but in the past I have made do with much smaller space, using the top of a cupboard as a working area.

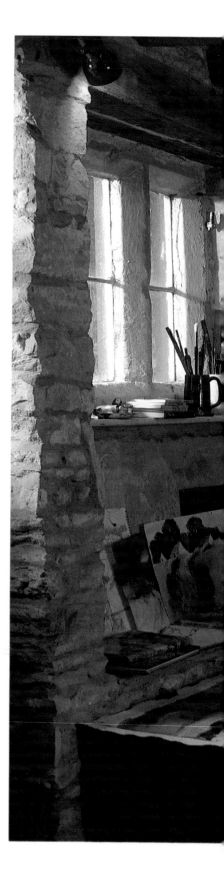

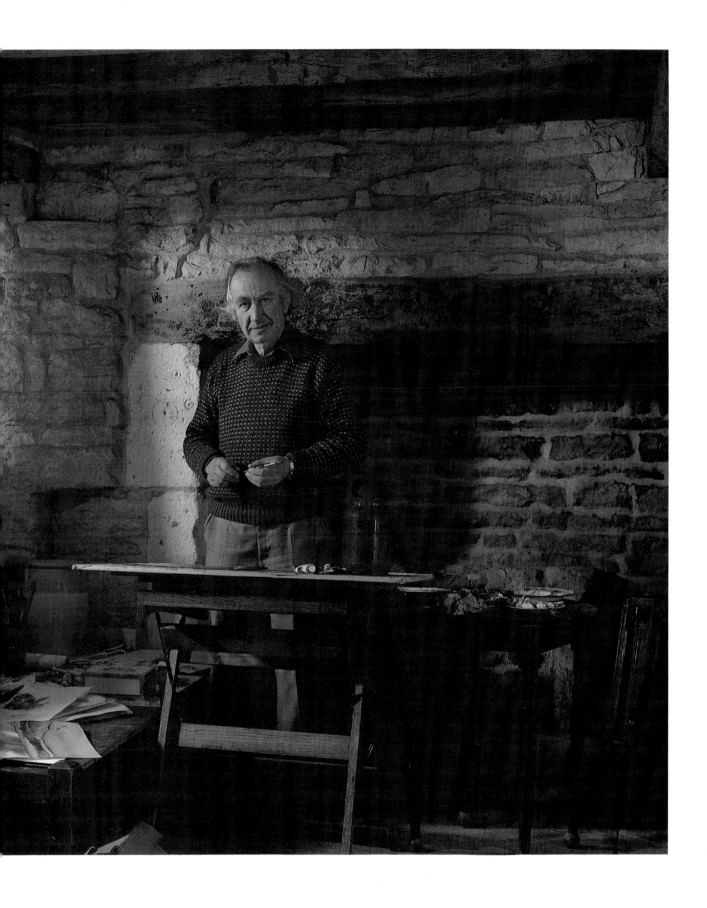

PART 2 *Beginnings*

Doodles

Here I combine the techniques we have discussed into one big doodle. These are fun and constructive. Do them freely without worrying about a good result. These fun things will help you understand the medium, and how watercolour behaves with different amounts of wetness.

Try brush strokes of wet colour into a very wet first wash. Then into not so wet paint, and then into nearly dry paint. Vary the wetness of the brush. Do it freely but try to observe how the brush strokes behave. Does the colour blend smoothly, or run away and disperse? Try it with different colours. These experiments cover all the techniques of traditional watercolour painting. Do them fairly large, not less than the page size of this book.

I also like to make smaller watercolour doodles in moments between painting. I regard these, too, as fun things for the sheer pleasure of handling the brush and paint and partly as exciting exercises. At one moment I use the tip of the brush to draw lines and curves, then the side of the brush to produce areas of colour, then back to the tip, to make dots and dashes. It is a continuous movement of brush and colour. Big sweeps, nervous dots, with the brush held loosely between fingers and thumb, and the hand pivoting and twirling from the wrist. The continuity of movement is exciting—a kind of flirtation between brush and colour.

These playful projects do have practical value. Brush and colour movements are the vocabulary of watercolour and should be instinctive, leaving the mind free to concentrate on the idea that prompted the painting.

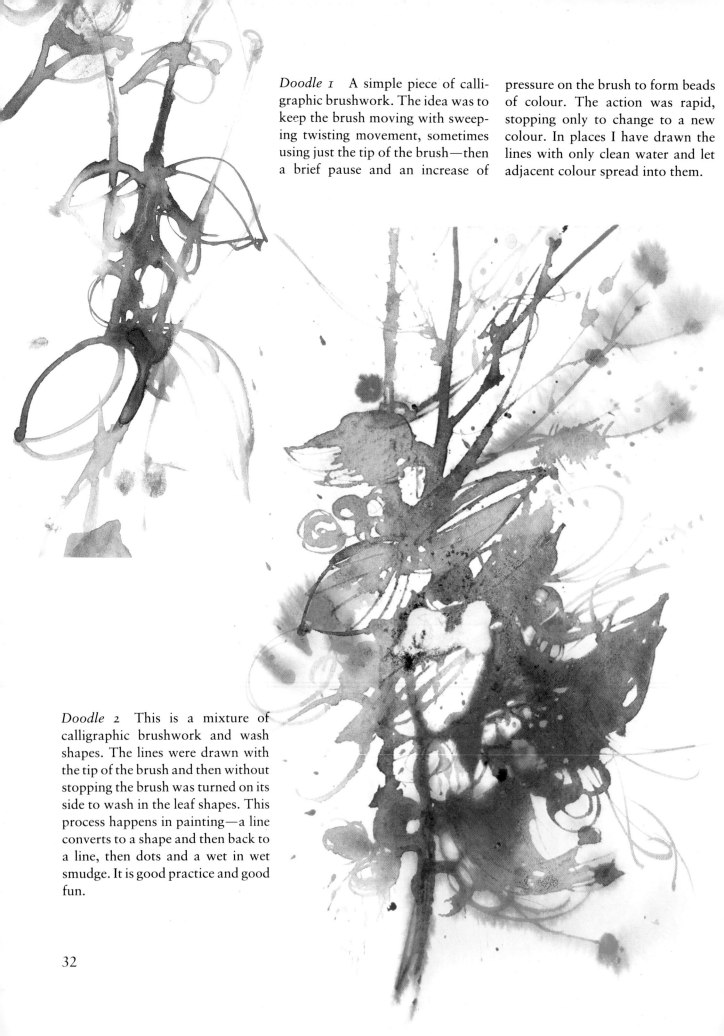

Doodle 1 A simple piece of calligraphic brushwork. The idea was to keep the brush moving with sweeping twisting movement, sometimes using just the tip of the brush—then a brief pause and an increase of pressure on the brush to form beads of colour. The action was rapid, stopping only to change to a new colour. In places I have drawn the lines with only clean water and let adjacent colour spread into them.

Doodle 2 This is a mixture of calligraphic brushwork and wash shapes. The lines were drawn with the tip of the brush and then without stopping the brush was turned on its side to wash in the leaf shapes. This process happens in painting—a line converts to a shape and then back to a line, then dots and a wet in wet smudge. It is good practice and good fun.

32

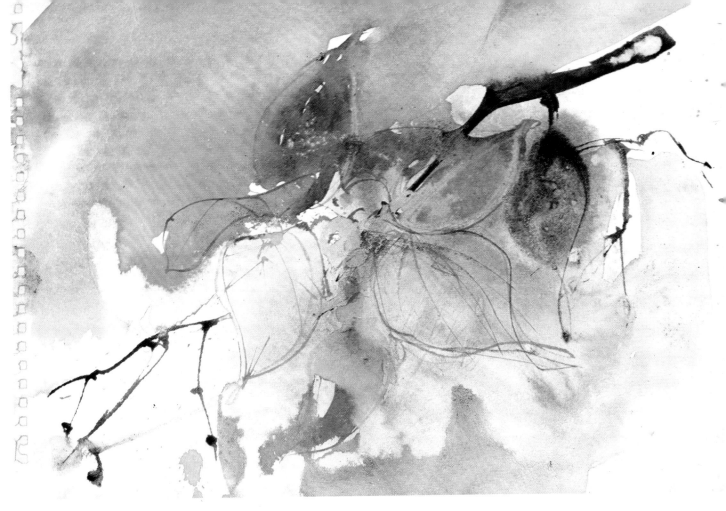

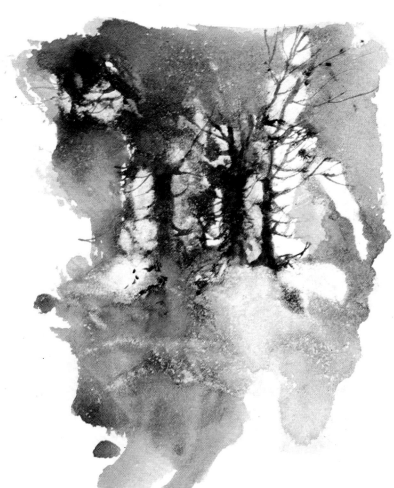

Doodle 3 (*above*) A doodle of wet into wet washes. I wet random parts of the paper with clean water and left parts dry so that the first colour washes softened into the wet paper but dried hard-edged on the dry parts. The leaf suggestions and the twig are calligraphic drawing.

Doodle 4 (*left*) This started with a wash of colour, using the side of the brush to shape the tree mass and the foreground. This was one wet in wet wash of changing colour. I left white paper shapes within the tree mass across which I finally flicked a few branches. These few branches convert a seemingly random shaped wash into a tree group. I like to keep explanation to a minimum.

33

Beginnings

From doodles, we start to progress to what I like to describe as 'beginnings'. When Turner died, he left a mass of 20,000 previously unseen works. These include some 300 watercolour sketches subsequently catalogued and labelled 'Colour Beginnings'. These are private colour notes, personal explorations and ideas with little literal information.

Probably most of us in our own way hoard sketches or first attempts, or uncertainties, to be looked at later with a fresh eye, for further development; or they might prompt an idea for a new painting. My storage cupboard is full of these private notes and jottings. Frequently, I like to make my own 'beginnings', starting with a particular notion, which develops according to sudden impulses. One brush stroke prompts another. They offer the enjoyment of a doodle, but are slightly more substantial in purpose. They have the *possibility* of further emphasis. One brush stroke might invite precise definition, to suggest, perhaps, a figure in a dream world of suffused colour. Or perhaps only slight definition, to just hint—a suggestion of form, an illusion. The following paintings show this sort of thing beginning to happen.

Doodle 5 This was a sudden impulse to paint a flower doodle. I immediately suppressed conscious thought of painting an actual flower construction. Instead I thought in terms of patterns of pink and light with curving movements suggested by petal shapes. The light is emphasised by the dark background, and the green surrounding wash converts into a leaf-like shape at the base.

This was just a doodle occupying a few minutes. It was done for the sheer enjoyment of putting paint on paper, with quick twisting brush-work and to hint briefly at the idea of flowers.

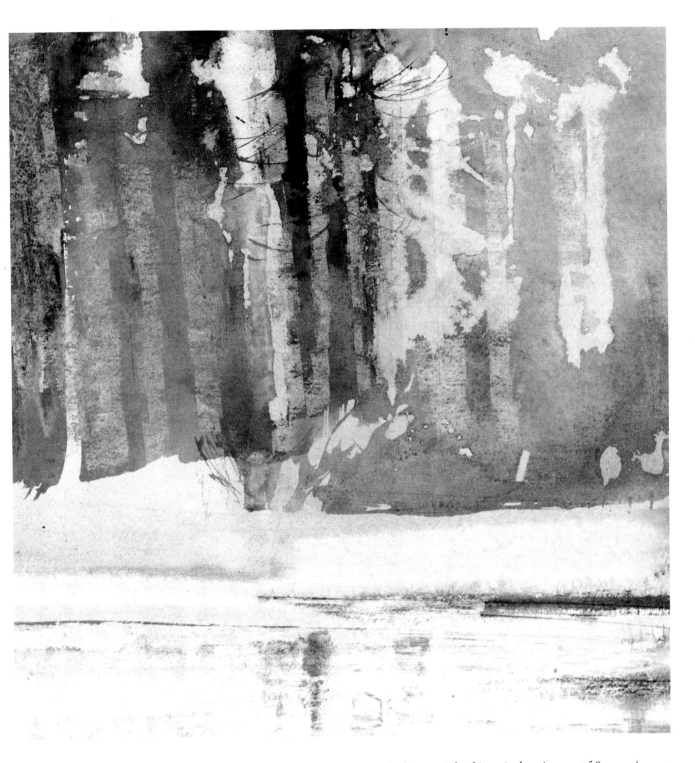

A beginning—this has been lying in a drawer for some time. Occasionally I take these beginnings out, to remind myself of them—then usually put them away again. Sometimes I throw them away to make room for more beginnings!

I do lots of them, a mixture of letting my hair down, having fun and practising my scales.

With this one I had in mind an image of Scots pines at the ege of water—a memory of something seen with light filtering through to create a mixture of hard and out of focus edges. I see that I have started to strengthen some of the tree trunks near the top of the paper. This is my normal painting procedure, starting with colour shapes and then strengthening parts selectively to give them positive identity.

This began with a pale wash of blue, followed by brush strokes of stronger blue in random directions. Next, stronger blue still was floated into the wet paint; dots of paint were flicked from a brush into wet paint and colour was gently lifted here and there. Gradually, hints of paint were introduced, with finally a dash of red, and possibly a too impetuous dab of black. The pleasure for me was in working quickly into wet paint, and forming soft shapes that emerge and then fade. I wanted to keep it balanced between fantasy and reality.

This 'people' beginning started without any preconceived image in mind. I simply brushed various colours over the paper, pinks, blue, and hints of yellow. While these were still wet I dribbled clean water into the centre of the paper so that this part remained wet as the surrounding part dried. Then, with a piece of paper I blotted away the wet area to obtain the light patch in the middle of the sketch. I thought that the light shape vaguely represented a group of people and so with a little brushwork I suggested the heads and left the rest to the imagination.

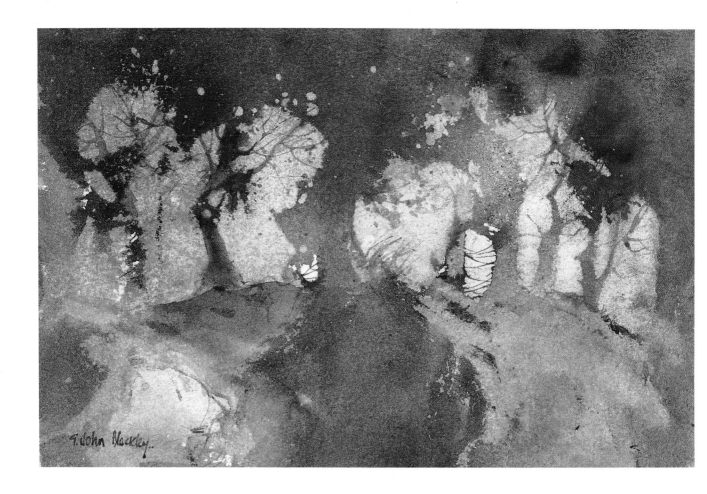

Here are two paintings done in the spirit of my earlier description of beginnings—'private colour notes, personal explorations and ideas'. But these two paintings are taken that bit further and perhaps they should be regarded as completed ideas rather than beginnings. They do indicate that large areas of a painting can be treated freely, with washes of colour, or brushmarks and that very little definitive description is necessary for these passages to possess literal meaning. Turner's work is a supreme example, with washes of colour flooding the paper and frequently worked over with small scratch-like brush strokes, flicks of paint and super-imposed transparent glazes. He produced brilliant veils of colour out of which suggestions of images emerged.

Although the difference between a 'beginning' and 'completeness' can be small I am not suggesting that the paper surface can be covered with any scribbled effect. It must begin and progress with integrity of purpose and in the context of the ultimate image.

This is a bit of playful indulgence with colour and form. Tree shapes, real or almost real, and definitely unreal in places. I tried to paint the edges just poised between softness and firmness, with the paper at a critical balance of dampness. I used thin paper, lightweight in substance and discreetly surfaced to help create the nuances of edge value. The light shapes between the tree shapes are important. They are big leaning shapes balanced against the small very round holes within the foliage. The foliage is one wash, relieved only by slight changes of colour and tone—not fussed about with descriptive detail. I thought of it as a bit of whimsical romanticism, or fantasy.

It is complete and so perhaps not a 'beginning'! But I want to show it here, near to my 'People' beginning. Comparison shows a similarity of thinking in terms of soft and firm-edged shapes. Both paintings have light parts seemingly bleached out of dark surrounds. In this painting, the light parts are so shaped that they describe the dark parts as recognisable tree forms. Each painting has a 'beginning' as light and dark shapes. The thinking begins in that way and it is merely the arrangement of one set of shapes that satisfies recognition: detail would be superfluous.

This idea has been with me for a long time, to paint a motif based on patterns in the sand made by the advancing and retreating tide. I have made many attempts. The difficulty has been to achieve the fluency of brushwork needed to describe the subtle curves and sculptured convolutions in the sand. It has been very much a hit and miss exercise over a period of years, worrying away at it on scraps of paper in private odd moments (I hoard scraps of paper) but the painting always seemed to lack the necessary dexterity, panache, or whatever.

I think these little private battles are important. There is always a feeling of excitement about it all, but essentially painting comes down to intensity of purpose, tenacity and hard work. I am showing this scrap of paper for whatever it is worth. Perhaps it does indicate a way of working, beginning from things seen and thought about. The actual form is minimal in content and this does help to concentrate and declare my particular interest. I am concerned with shapes and textures, with edges soft and hard: how hard, how soft, with things lost and found, the enigma of things. These are attitudes that mostly direct my painting (limitations, I sometimes wonder).

PART 3 *Colour and tone*

Of all the ingredients that make up a painting, colour probably makes the most immediate impact, but few of us are born with an inherent ability to use colour well. It has to be developed by observation and practice.

One of the biggest obstacles in developing this sense of colour is that we continue to think in terms of familiar and recognised colour names. We 'know' that grass is green, and so we paint it green. We 'know' that leaves are green and the tree branches brown, but these 'local' colours, as they are termed, are modified by their surroundings. Green, under a blue sky becomes blue-green and the branches tend towards grey.

The surface of the object also affects the colour change. If the green leaves are very wet and shiny, they will reflect the sky even more and appear quite silvery.

Imagine two polished vases standing side by side, one red and one blue. The red will reflect the blue and the blue will reflect the red, so that each vase will contain some purple.

Distance also has an effect. Colours tend to soften and change towards blue as they recede.

These few examples of colour behaviour suggest that no single colour can have an absolute existence: it is controlled by its environment. I believe that an awareness of this, coupled with searching observation, pro-vides a direct approach to developing colour sensibility and is more helpful than any amount of theorising with colour circles. Indeed, preoccupation with theory can stifle adventurous colour.

So, go out and look at colour, in nature and in paintings. Look how other painters use colour. Look for surprises—would you have thought of such colours? Try to see where the painter has intensified a colour for some purpose, or a small flick of unexpected colour, an imaginative, impulsive quirk by an individualist. Very often you will need to look really hard because an unlikely colour can look right by reason of the accompanying choice of colours. Notice how some colour areas are played down, muffled to emphasise a high note of adjacent colour.

Look for the richness of sombre colour, peaty browns, bronzes, charcoal and pewter greys, then look for the lighter 'dancing' colours, flecks of violet, pink greys, alabaster whites. We probably all have individual leanings to certain colour families and I enjoy painting warm, earthy coloured landscapes, but today I attempted to paint a piece of honeysuckle with its long scimitar shaped flowers graded from palest lemon to striking pink, almost magenta.

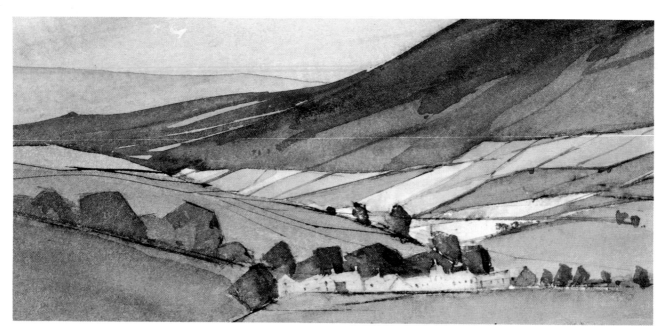

Weathered moorland—washes of peaty brown and bronze, with flickerings of red brush drawing.

Comment has been made that the pink foreground is a distraction, enough to raise some doubt in my mind. Did I really observe that colour, imagine it, or did I simply want to see it? But the sketch is a personal statement, in which the pink plays a part in recalling the sensations of the day. I am sure that the traces of red drawing, threading upwards through the sketch, indicate an intuitive purpose, to tie the transparent pink into the painting, linking up with the hint of pink at the top of the paper. I notice also that I have overpainted the bronze with a glaze of transparent red, diluted to a kind of pink.

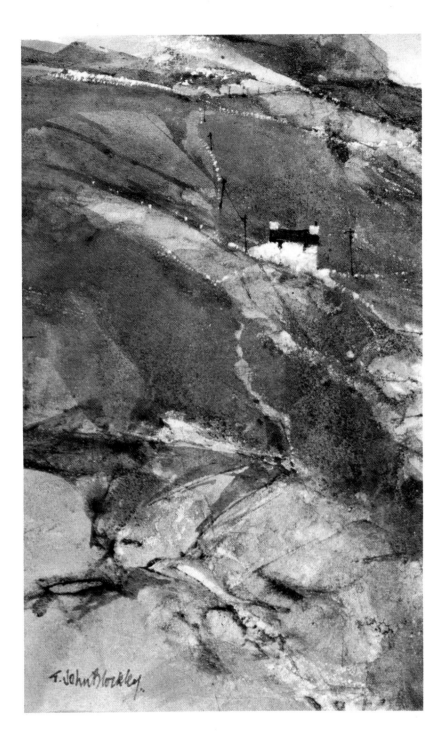

Opposite: painted on the spot in Wharfedale, Yorkshire. Muted colour is used to highlight the middle distance. I deliberately greyed the foreground to a neutral anonymous tint so that colour is contained and located in the one area. Notice that except for the sky, the painting is made with hard-edged, flat, overlaid washes.

Colour mixing

I have suggested above that colour appreciation is best achieved by observation, but a brief explanation of how colour is made up might be helpful in our approach to colour mixing.

Light from the sun is a mixture of violet, blue, green, yellow, orange, red. We are familiar with these colours having seen them prismatically split to form a rainbow and we will have seen that the colours are not separated into separate bands but blend together. Blue gradually changes to blue-green and then to green which in turn passes through green-yellow to yellow. This process is continuous; yellow passes through orange to red, and red through violet to blue and so the circle continues.

The colour of an object depends upon the light falling on it. When the light from the sun falls on an object, the object absorbs some of the spectral colours and reflects others. For example, when we see a red object it is because that particular object has absorbed all the rainbow colours except red. The red is reflected back to us and so we see the object as red. It is the reflected colour that we see and this can be quite subtle. We see a tree as green but what sort of green? Is it inclined to yellow-green or to blue-green? So now, when we look at nature, we need to look hard for colour subtlety and then consider how to achieve this with paint. Sometimes, a colour straight from the tube, or pan, sufficiently represents the colour of the object we are painting. For example, I occasionally use indigo for the colour of a stormy sky, but mostly I need to adjust it slightly towards grey, by adding Paynes grey, or more blue by adding a little Prussian blue.

Obviously, the infinite number of colour subtleties seen in nature can never be manufactured and squeezed into tubes or pans and so we have to try to mix them with the colours available to us. We see a red house. What kind of red? Towards purple? Or towards orange? Then we choose the nearest red in our paint box. Alizarin crimson is a red, inclined to purple. If it is not sufficiently purple add a little blue to a rather larger quantity of the red. What kind of blue? Pale blue or dark blue? You discover this by trial, mixing various blues in turn with the alizarin crimson. If your subject is red and inclined to orange, try cadmium red, or vermilion mixed with a small amount of yellow. So, colour can be influenced in certain directions by discreet mixing with another colour.

Colour strips

Colours can also be mixed to produce another colour. Blue mixed with yellow produces green. I have painted a few examples in strip form. The first strip shows the results of mixing indigo with other colours, then I show the results of mixing pthalo blue, Hooker's green, yellow ochre and burnt umber with other colours. You should experiment with your choice of mixtures.

Indigo

Burnt sienna

Indigo

Raw umber

Indigo mixed with burnt sienna

Indigo mixed with raw umber

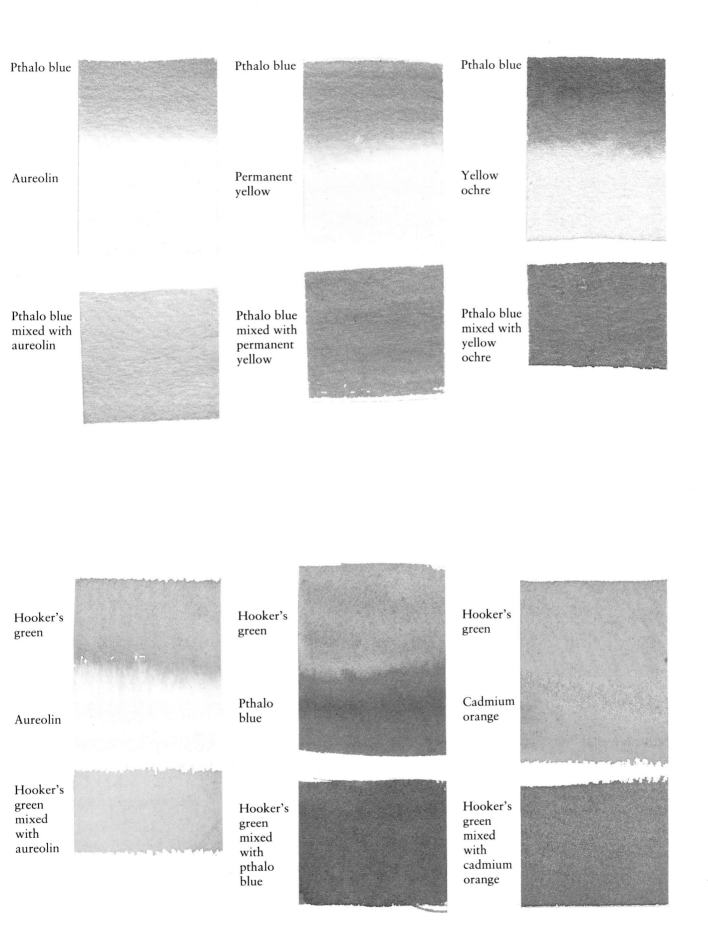

Pthalo blue

Aureolin

Pthalo blue

Permanent yellow

Pthalo blue

Yellow ochre

Pthalo blue mixed with aureolin

Pthalo blue mixed with permanent yellow

Pthalo blue mixed with yellow ochre

Hooker's green

Aureolin

Hooker's green

Pthalo blue

Hooker's green

Cadmium orange

Hooker's green mixed with aureolin

Hooker's green mixed with pthalo blue

Hooker's green mixed with cadmium orange

Yellow
ochre

Alizarin
crimson

Yellow
ochre

Cadmium
red

Yellow
ochre

Burnt
sienna

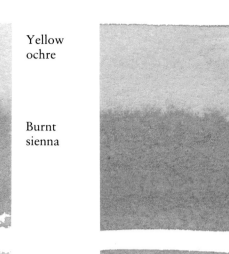

Yellow
ochre
mixed with
alizarin
crimson

Yellow
ochre
mixed with
cadmium
red

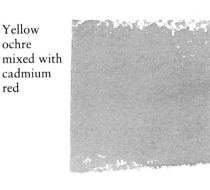

Yellow
ochre
mixed with
burnt
sienna

Burnt
umber

Pthalo blue

Burnt
umber

Indigo

Burnt
umber

Neutral
tint

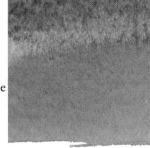

Burnt
umber and
pthalo blue
mixed
together

Burnt
umber and
indigo
mixed
together

Burnt
umber and
neutral tint
mixed
together

Burnt sienna painted over yellow ochre

Burnt sienna over indigo

Another experiment is to paint one colour over a different colour. Paint a small area of yellow. When it is dry overpaint it with green. Compare this with painting yellow over green. Remember the first colour must be bone dry. Now try blue over yellow and yellow over blue.

Burnt sienna painted over permanent yellow

Burnt umber over indigo

Colour selection

Paint manufacturers produce a wide range of colour to choose from. I have beside me a chart of watercolours containing nearly one hundred colours. My selection is:

alizarin crimson
cadmium red
burnt umber
raw sienna
lemon yellow
aureolin
indigo
Paynes grey
pthalo blue

I can mix most colours that I want with this 'main' selection, but I also carry, for occasional use, Hooker's green dark, cobalt blue, and sometimes I add (for me) a 'way-out' colour such as cobalt violet. Sepia is a lovely brown, burnt sienna is a lovely reddish brown. In past days there were doubts about fading, but most colours today are reliable. The colours listed here can be relied on not to fade.

This is my paint box, shown here rather less than exact size: it is, in fact, about the size of this book when opened out. Starting at the bottom left corner the colours are: cobalt blue, then a 'spare' place, light red, cobalt violet, 'spare', yellow ochre, raw sienna, cadmium red, Hookers green, pthalo blue, indigo, Paynes grey, lamp black, aureolin, lemon yellow, white (rarely used), alizarin crimson, burnt umber. The 'spare' places are for trying out new colours, and occasionally previously disliked colours.

It might seem more logical to keep colour families together and many painters would be critical of my casual arrangement. The cadmium red looks startlingly displaced from the other reds. My arrangement probably came about through early ignorance, or impatience, but there is some sense in it. I frequently modify cadmium red with yellow ochre, and aureolin with lemon yellow, indigo with Paynes grey and so it is convenient to place them as neighbours. Sometimes I simultaneously pick up harmonious neighbouring colours with a wide flat brush so that one brush stroke across damp paper produces subtle blending of two colours.

The box has large wells for mixing colours. I clean the largest of these frequently while painting, but the others are never cleaned. These dried previous colour mixings might be criticised as dirty and untidy but I would be inhibited by starting with an immaculate colour box. For me, these spillages of yesterday's colour are exciting and stimulating, and I can almost read 'beginnings' of paintings and landscape suggestions within them. They are helpful in overcoming the initial anxiety of starting work on the sheet of white paper. The dried mixings have practical value also, they can be picked up with a wet brush to provide subtle colour touches in today's painting.

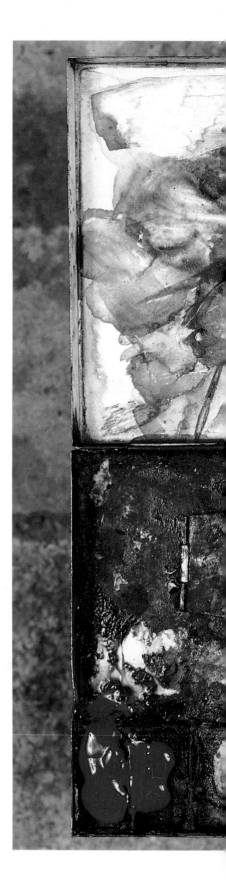

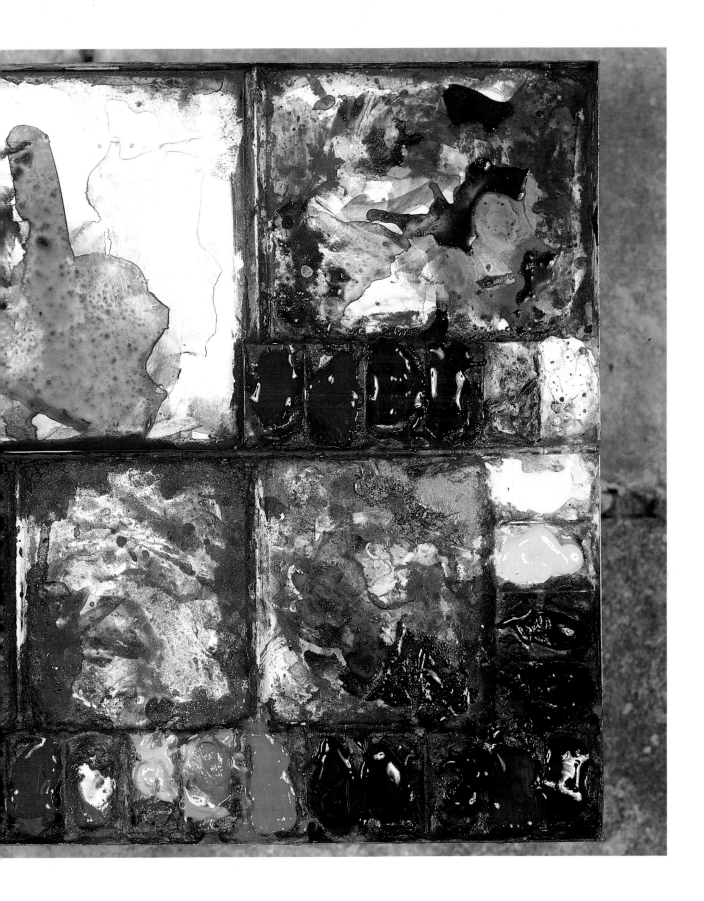

Colour extracts

A number of colours can be mixed from only a few colours and to illustrate this I have taken extracts from my paintings. These are reproduced same size as the originals and are intended to identify some colour mixtures and show them in the context of actual paintings rather than as mere specimens.

These examples indicate that a variety of colours can be obtained by mixing and it is constructive and fun to experiment with colour mixes.

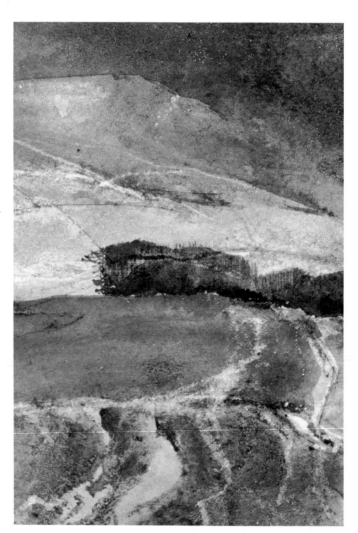

Indigo

Dilute indigo

Very dilute indigo plus lemon yellow

Raw sienna plus cadmium red

Burnt umber plus indigo

Burnt umber

Alizarin crimson plus indigo

Aureolin plus indigo

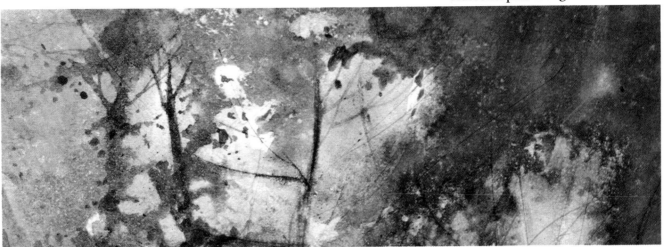

Pale green:
aureolin plus
cobalt

Darker greens:
aureolin plus
dilute indigo

Indigo

Yellow:
aureolin

Copper:
Aureolin plus
cadmium red

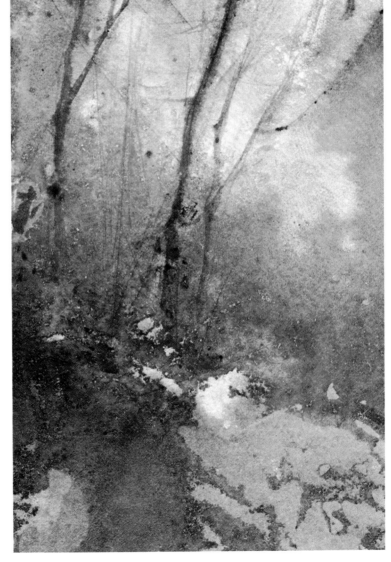

Green:
aureolin
plus
cobalt
blue

Brown:
Paynes grey
plus cadmium red

Painting with a few colours

I do advise those just starting to paint to proceed systematically. Aim to get to know a few colours at a time, and then gradually add to your vocabulary. Paint some simple landscapes, or indoor things, with just a few colours. Delightful results can be obtained by painting with one colour, say indigo, and then towards the end of the painting introducing a hint of another colour, only just noticeable, perhaps raw umber, or raw sienna. Some of the early water-colourists achieved delightful results with almost monochromatic work.

Mountain light

This painting is about a mountain side speckled with light reflected from boulders, where eroded scree is scattered down the slopes.

The mountain side is clothed with trees and it was important to paint them as a mass rather than individually. Lots of separately painted trees would detract from the sparkling light. I painted the trees with one wash, shaping the top to describe rounded tree tops. Branches and trunks were stroked with a brush into the damp wash.

The painting began with a wash all over of Paynes grey mixed with diluted alizarin crimson. The trees are Paynes grey with additions of burnt umber in places. So, mostly only one colour, Paynes grey, is used, with occasional additions of the other two colours. The larger reflected lights were blotted out with my finger wrapped in a rag, and the small lights with a stick (the end of my brush) wrapped in rag.

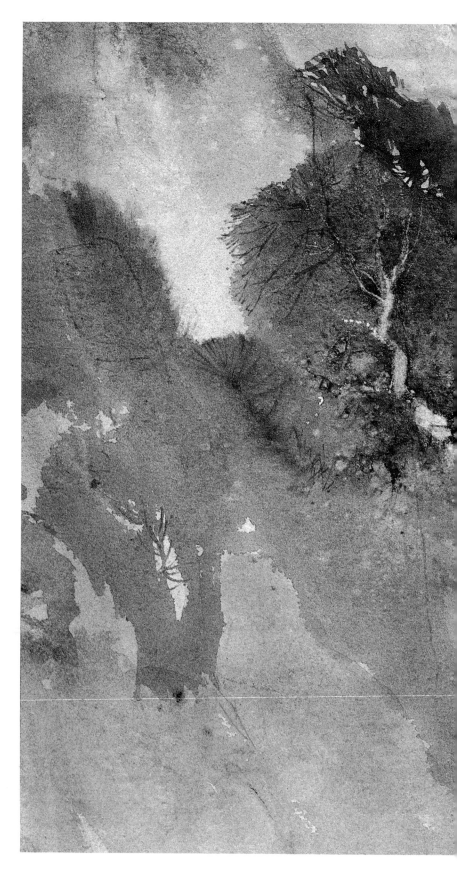

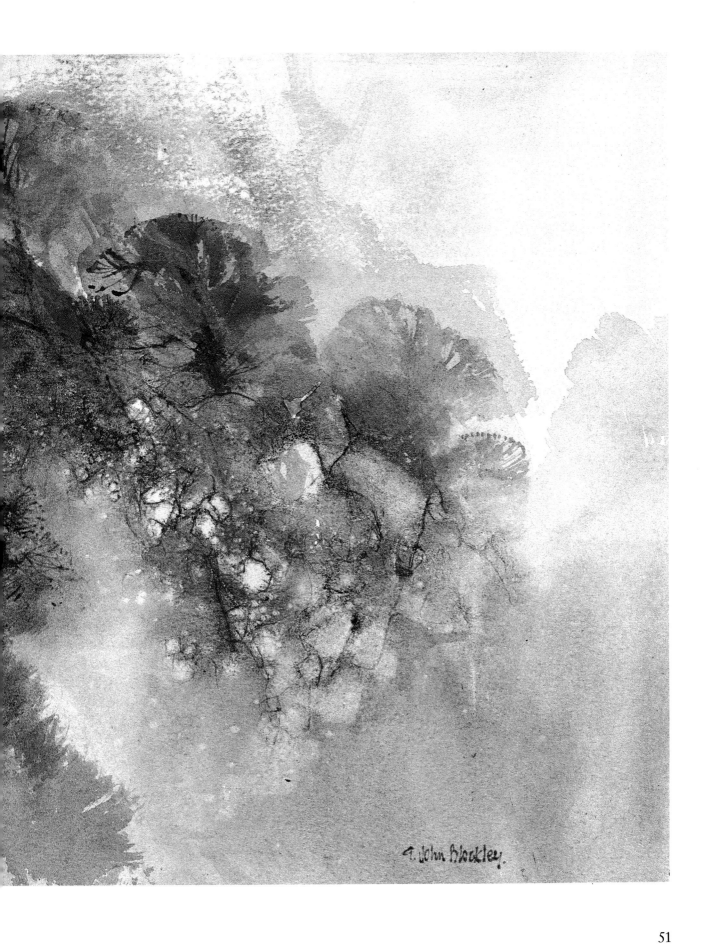

© John Blockley.

Warm and cool colours

Colours close to red are termed warm colours. My landscape sketch (below) shows a landscape painted with warm colours, all of them being closely related to red.

The other sketch shows a landscape in cool colours, all of them being related to blue.

These little sketches are inventions of mine to illustrate the idea of warm and cool colour, but in nature, warm and cool colours are rarely separated quite so definitely. They mostly exist together.

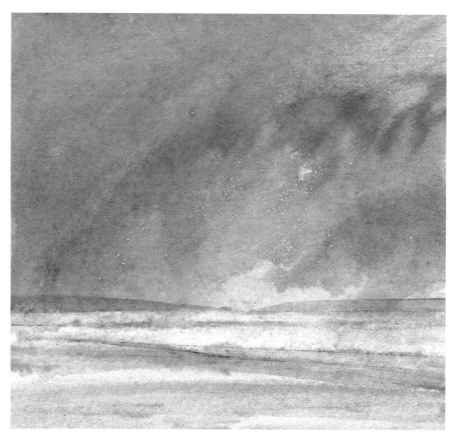

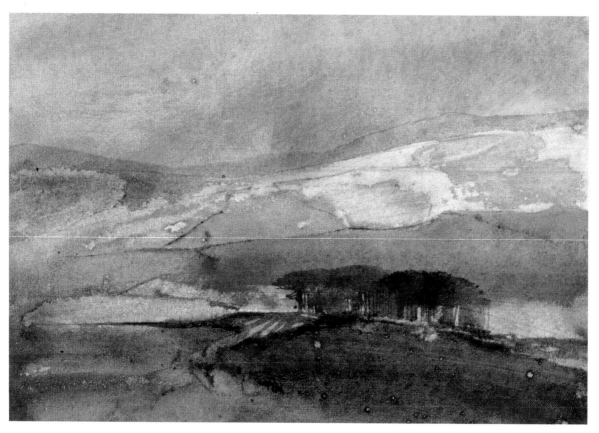

Recession

Colours in the landscape tend to cool with distance, they lose their colour and incline towards blue or blue-grey. Try an experiment. Paint a small simple landscape with a building in the foreground and a building in the distance. Paint the foreground with burnt umber and the distance with cobalt, very pale. Paint the roof of both buildings with the same red. You will see that the distant roof will jump forward and not sit properly in the distance. The distant roofs should be cooler.

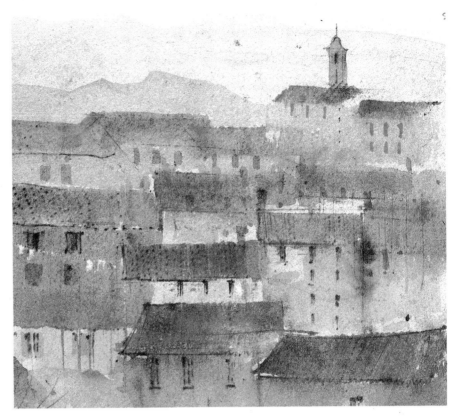

Above: this is a quick imagined sketch of buildings with red roofs. Even if all the roofs are red, we paint the distant ones with cool grey-blue.

Below: in this small sketch the foreground green contains yellow and so it is a warm green. I have cooled this to give recession by adding blue towards the distance.

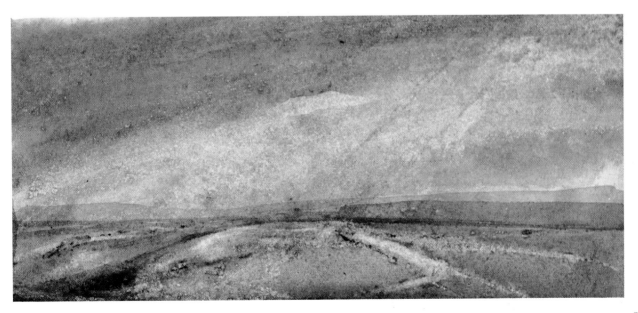

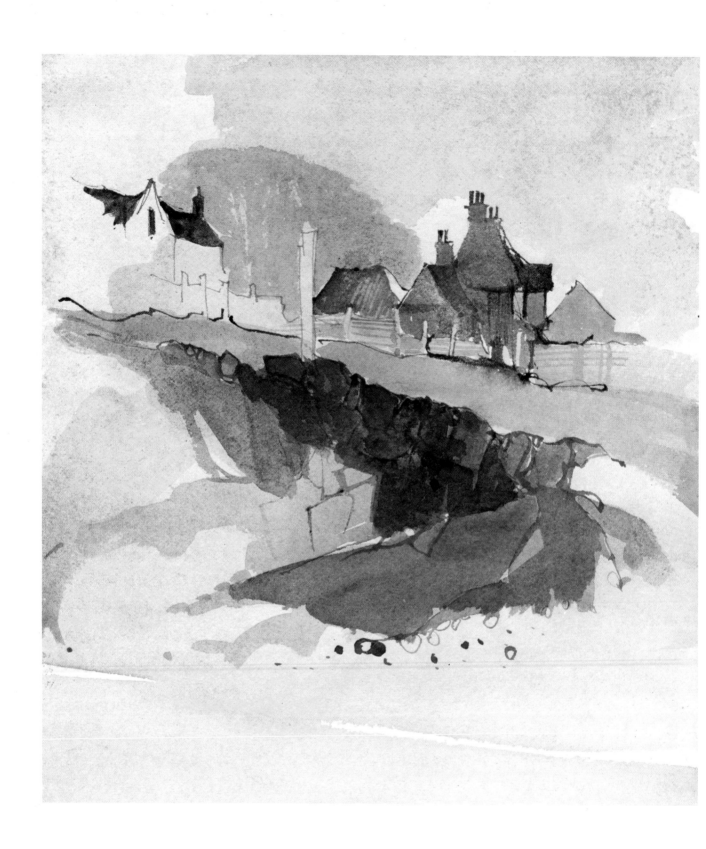

Combined warm and cool colour

My sketches of the village called Overy Staithe contain various values of warm colour (reds and browns) and varying intensities of cool (blue) colour.

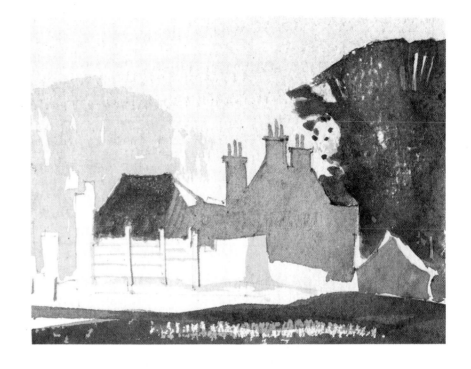

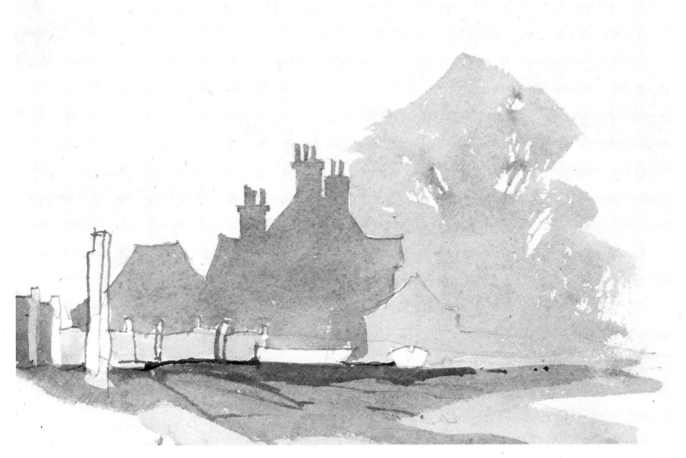

Tone

We have discussed how objects become cooler with distance. Objects also tend to become paler with distance. So, in addition to our use of warm and cool colour to obtain recession we now have dark and light, known as tone. In order to become familiar with this it is a good idea to forget colour for a while and paint in monochrome. Try a painting in any one colour—I suggest Paynes grey—and try to suggest recession by painting distant objects with paler washes.

It is not always easy to judge tone when working with colour. This is proved by seeing colour paintings photographed in black and white; often a part of the photograph appears to jump out of its surroundings, showing that the artist, when considering the colour of that part, had not considered its tonal values and has painted the passage too light or too dark.

A very old trick is to look at the subject through closed eyelashes to eliminate details and simplify the scene into broad tonal masses.

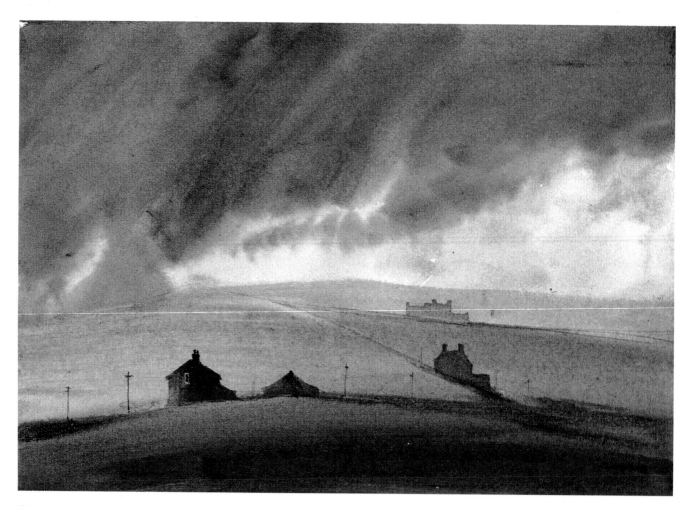

Tonal sketches

These sketches were painted with indigo watercolour as simple planes of tone. They indicate how distance can be implied on a piece of flat paper, by regulating the tonal values. This tonal recession is known as 'aerial perspective'.

Such small sketches are enjoyable to do, and can be effective in themselves. They certainly help towards an appreciation of painting in tonal values.

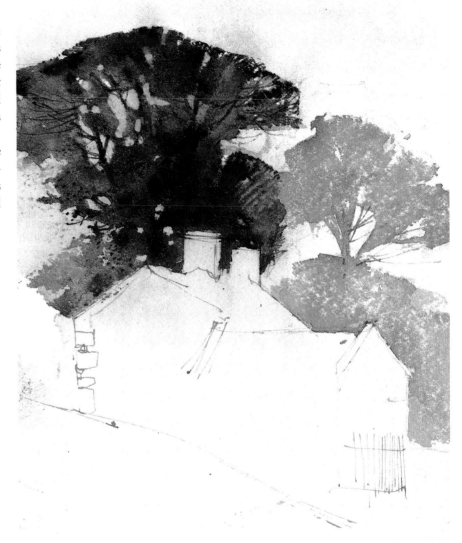

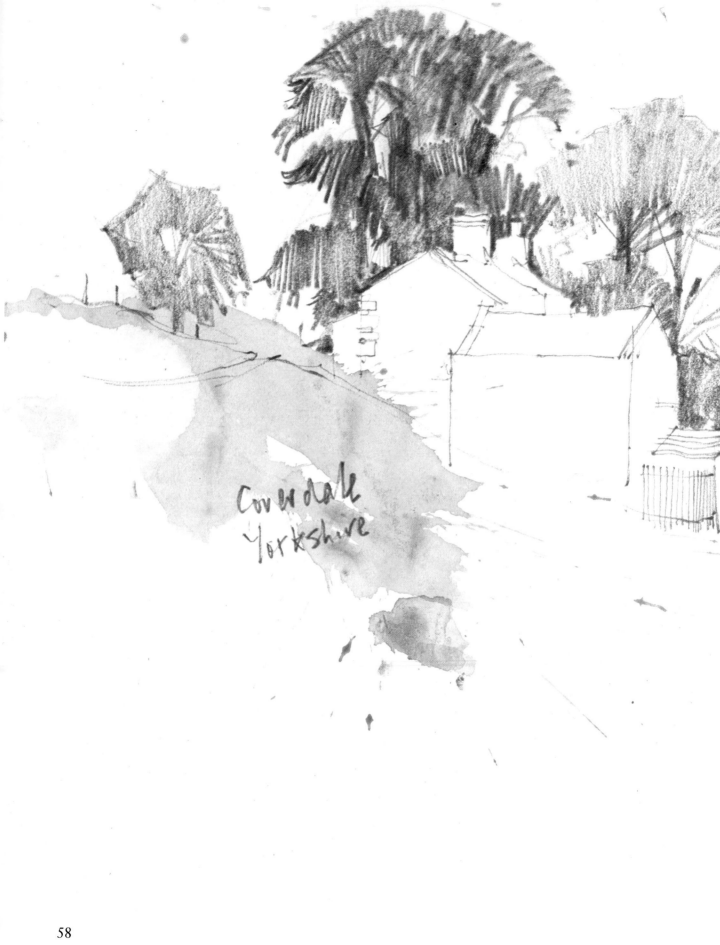

Coverdale
Yorkshire

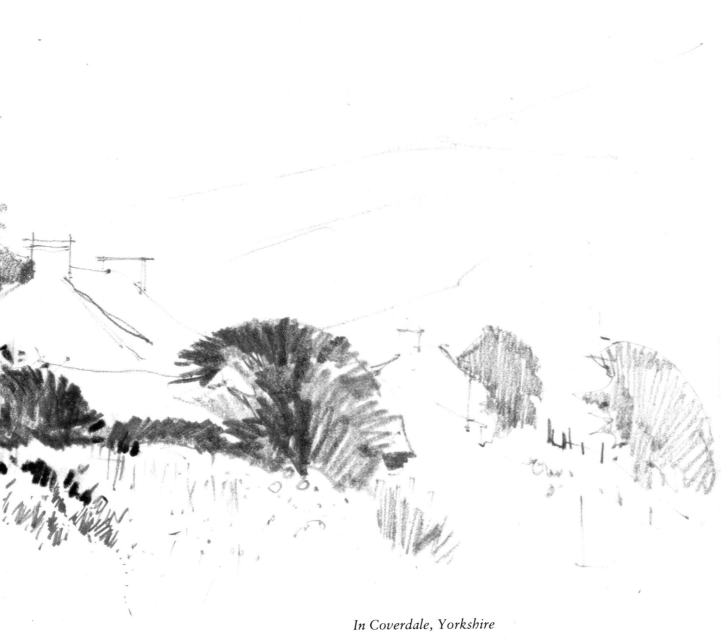

In Coverdale, Yorkshire

This pencil drawing was made on the spot. I saw the buildings as light shapes against the dark masses of the trees and so I outlined them lightly but precisely with the point of the pencil. Then I blocked in the mass of the trees with broad sideways strokes to produce slabs of tone. In this sketch tone is used principally as a pattern making device, with solid areas placed against fine linework. It was drawn with a painter's outlook. I can imagine a dilute wash over the paper to represent the pale tones of sky, buildings and foreground, then dark washes for the tree masses, encompassing the buildings.

59

Colour and tone combined

The combination of colour and tone is extremely useful in helping to convey a sense of distance and space on a flat piece of watercolour paper.

My colour sketch with warm brown trees and the blue trees beyond, gives a sense of distance. This has been helped also by painting the trees successively smaller, but the effect would have been even greater by painting the diminishing trees in successively cooler colours. The tone of the nearest, larger group, might also have been slightly darker.

My sketch 'Mountain sky' (opposite) has dark blue in the distant left mountain and in the foreground. Is my judgement wrong? In fact, the foreground blue is slightly darker than the distant blue, and is also made to appear darker by contrasting it with a very pale foreground tone. But perhaps I should not have used blue—though I wanted it as a kind of link with the background. So should it be even darker, or a warmer blue? How do I make a warmer blue? I could obtain it by mixing a warm colour with blue, or, preferably, paint all the foreground red, then glaze over it with a wash of blue.

I have said that cool colours recede and warm colours advance. I have also said that dark tones advance and paler tones recede. However, it should be borne in mind that a strong dark blue *can* advance in front of a weaker red.

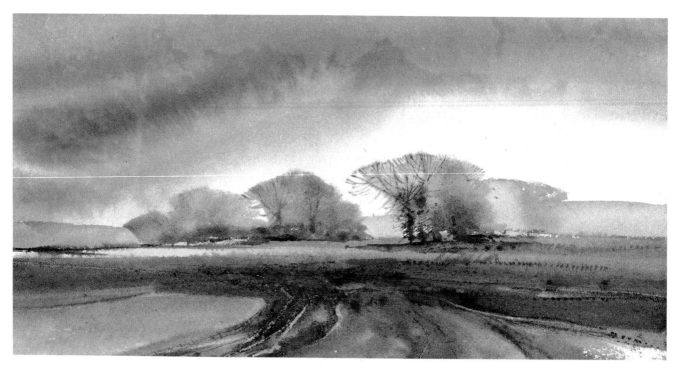

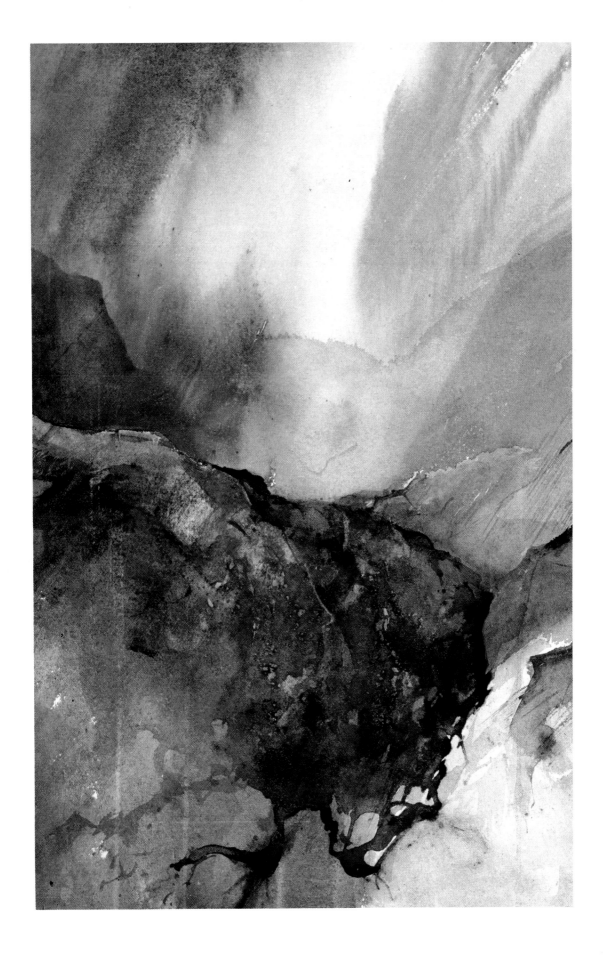

Tonal scale

In terms of a painting, tone extends from white to black, with all the shades of greyness in between. Some painters use this range of tone in their paintings, to give strong dramatic effect. Others work over a limited scale ranging from white paper to a grey tone for their darkest tone.

Paintings ranging over the darker tones are referred to as low key, and the lighter scale of tones as high key. I have heard the latter type referred to as 'wishy washy' but the truth is that such paintings can be beautifully rendered, suggestive and containing sensitive nuances to be savoured and relished.

The important consideration is that whatever key we wish to work in, we have to avoid scattered, abrupt changes of tone. Strong tonal contrasts should be placed in important areas to which we wish to draw attention. If they are scattered indiscriminately over the painting, the result will be busy and confusing.

Busy tone, and incorrect tone can be the most irritating faults in a painting.

The small study opposite started with a wash all over of pink, (very diluted cadmium red). The wash was left to dry before painting the clouds and foreground with mixtures of cadmium red and French ultramarine.

French ultramarine has the property of precipitating from a wet wash and collecting in the grain of the paper. This has happened in my painting here, speckling the cadmium red wash with precipitated blue. Beware of relying on the process too often. It can become an easy way of creating an effect.

The ship is painted as a simple silhouette steaming out over the picture. The diagonal movement of the clouds also slopes in the direction of the ship, out of the picture. I am sure someone will say that we shouldn't lead the eye out of the painting, and I would agree that it is a reasonable rule to follow, but in this painting it doesn't seem to matter. Perhaps it would be more obvious in a low key painting of stronger contrasts. Don't be too conditioned by the rule book.

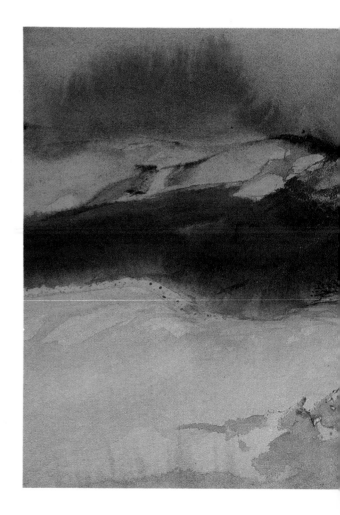

This was painted on the spot. The sky and mountain are painted in low tones. In fact, the sky was much brighter—but I painted it in low key to highlight the strip of yellow-green grass and the foreground. I call this 'telling a lie to emphasise a truth'. The obvious point is that a light is only really light when surrounded by a dark. I have merely exaggerated the dark.

Decisions such as this are fairly easily made in the studio, but it is more difficult to make such changes on the spot. I've had a few experiences when onlookers have looked at me strangely when I've painted a bright blue sky with dark indigo.

Notice that I've introduced a light area along the top of the mountain, but I was careful to make this less light than the grass.

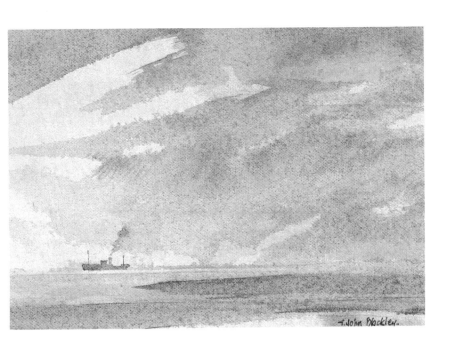

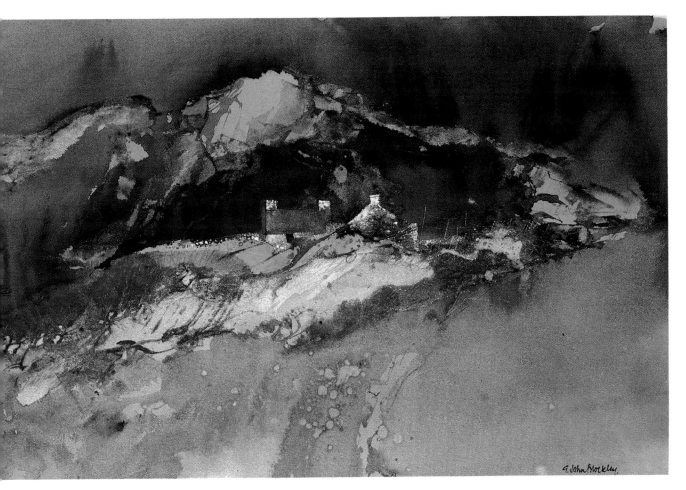

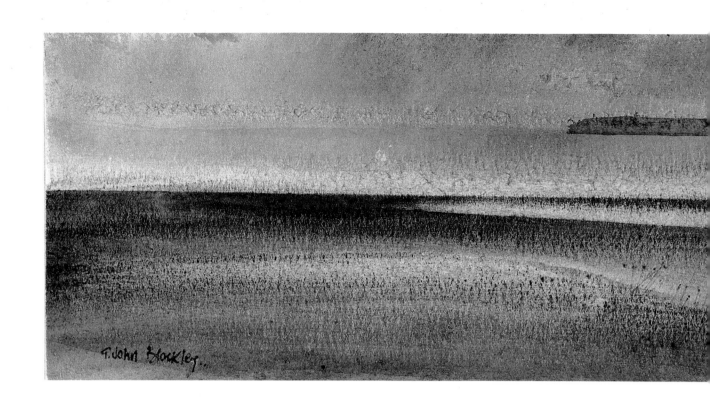

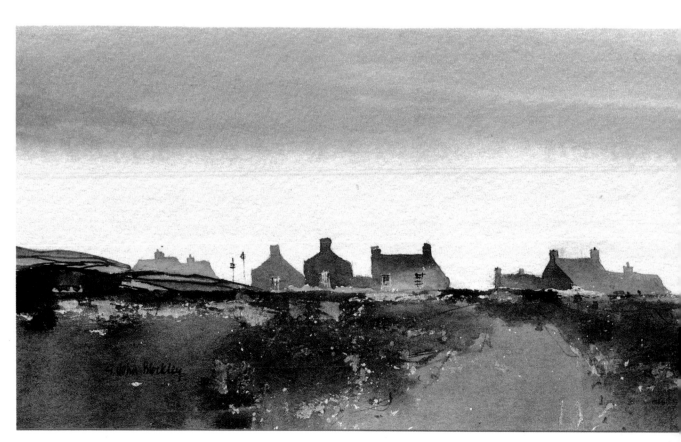

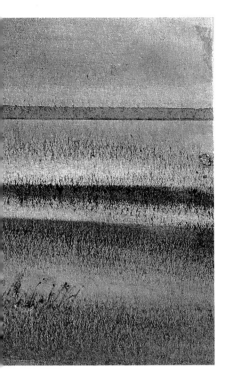

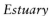

Estuary

In this painting I wanted to show dull light reflected from the water and from the tide-washed land.

The painting is in a relatively high key except for the continuous passage of soft-edged dark drifting through it. The tone of this dark increases in value towards its upper edge and helps to pull the eye into the painting. This dark passage lies comfortably in the painting because it is painted softly into damp paper in a continuous movement. Hard-edged, jerky darks would destroy the serenity of the scene. Only two colours are used. The sky, water and headland are Paynes grey, very dilute and the foreground is Paynes grey mixed with burnt umber.

It was essential to paint in transparent washes to preserve the white of the paper and so suggest the sheen of the water, and I wanted it discreetly speckled to imply a sense of underlying land.

The painting began with a wash of dilute Paynes grey all over the paper; while it was still wet, very wet burnt umber was brushed into the lower half. Like French ultramarine, burnt umber, when very dilute, has the property of precipitating out of the wash and settling in the grain of the paper to produce a speckled effect. This action can be made very pronounced by rocking the paper to make the wash swill from side to side over the paper surface. I used the process in this painting and waited until the shine began to disappear from the surface. This told me that the water was absorbed by the paper and that the precipitated pigment was fairly well settled in the grain of the paper. Then I swiftly swept brushfuls of clean water across the paper to wash away much of the precipitation, leaving only the finest grains to give the discreet speckling. This was an anxious moment. A too wet brush, or too many brush strokes could have washed all the particles away. I happen to have achieved the effect I wanted—by good judgement, I now ask, or luck? Such is the nature of watercolour!

I wanted the dark passage to lead gently into the painting, and finish with a firm hard upper edge to intensify this darkest area of tone. I obtained this straight line by using the edge of my paint box as a ruler to draw the brush along.

Cottages—Wales

The cottages in Wales are of solid 'no-nonsense' construction, built of stone, with thick walls, slated roofs and often with simple porches over the door. They are both functional and aesthetically satisfying. Their chunky shapes are right for the rugged landscape, and the big solid chimneys make characterful silhouettes when seen against the sky. It would seem obvious that the rugged landscape and solid cottages should be painted with emphatic, no fuss statements. My sketch attempts this. I thought that the character of the buildings were best expressed in direct, low tone washes and placed against a pale, high key sky. The foreground is painted with the minimum of fuss, so that buildings and ground integrate as one dark tone.

Painting from light to dark tones

The traditional way of working with watercolour is to work from light tones towards the darker tones. The process begins with brushing colours over the paper, the colours representing all the lightest colours seen in the subject. This process creates an atmospheric-like effect of veils of colour all blending together. All the examples in the book so far employed this procedure. Next, further colours are worked into the damp paper so that soft-edged impressions of the subject begin to emerge. The process continues, using the techniques of adding, strengthening, and lifting colour demonstrated at the beginning of the book. As the painting dries, hard-edged details can be added, progressively getting darker, so that the final stage is to add the darkest part of the painting.

The advantage of this method, is that the paper is covered quickly, helping to overcome the anxieties we all feel when faced with the white sheet of paper. The first washes of changing colour also act as a unifying base helping to hold the subsequent brushwork together. The figures shown here illustrate the process.

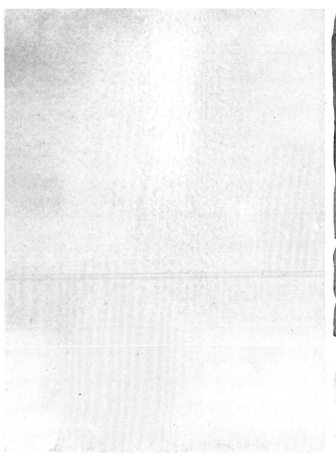

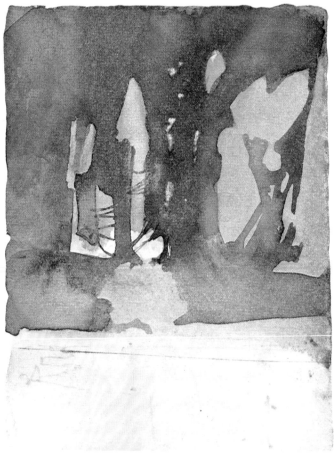

1 I started with a pale wash of indigo all over, then brush strokes of aureolin were made into the damp paper.

2 When the paper was dry, a wash of indigo, with additions of aureolin, was painted, leaving patches of stage 1 exposed.

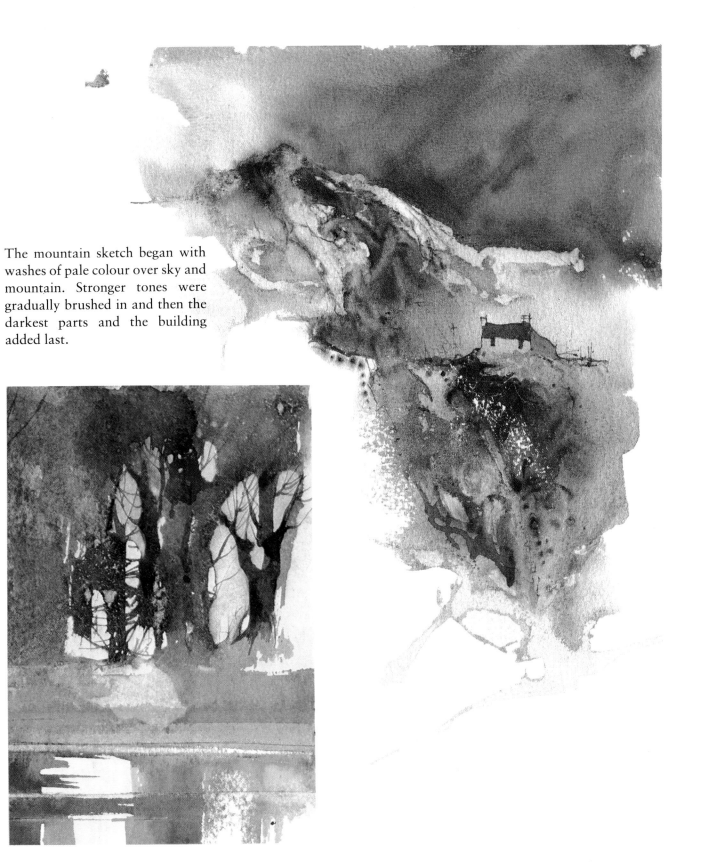

The mountain sketch began with washes of pale colour over sky and mountain. Stronger tones were gradually brushed in and then the darkest parts and the building added last.

3 The tree trunks and branches were shaped up and drawn with a fine brush and the reflections added.

Paintings made this way can have a wonderfully fluid quality, with colours melting together, features emerging and fading away.

Dark to light process

Some painters prefer to work in the opposite direction. They start by painting the darkest part of the subject, straight away onto the white paper, then they apply the lightest colours just as in the light to dark process, and gradually introduce the darker tones. By registering the darkest and the lightest tones at the beginning they provide themselves with a tonal scale to which they can relate all the other tonal values seen in the subject.

In my early days of trying this method I could never decide which *was* the darkest tone, as several darks seemed equally dark. The remedy is to be selective and choose one dark as the darkest value and then relate other tones to it during the painting progress.

My sketch book drawing of a cottage and barn illustrates the dilemma. I have shown windows and doors all of equal darkness so that they compete, and are equally compelling to the viewer's eye. Even if they did appear equally dark it would be more satisfactory to choose one as the principal dark.

White

On Greenhow
Wharfdale
Yorkshire

Light toned features

My thumbnail sketch shows a pale pink cottage against a dark tree mass. With an opaque medium such as oil, I could have painted the pale building on the top of the dark trees, but this is clearly not possible with transparent watercolour. I started my sketch with a wash of pink over the paper, allowed it to dry, and painted the dark trees over the pink wash, leaving the shape of the cottage. In this sequence of painting, the background dark defines the cottage. It is a simple process.

 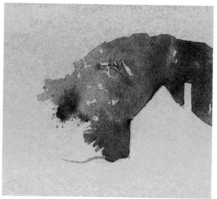

Many inexperienced painters would paint the light cottage first, carefully shaping it on the white paper, and then paint the dark background around it. Similarly, many inexperienced painters would paint the sky first, leaving white paper for the tree, then paint the tree, leaving white paper for the cottage, and then fill in the cottage. This is a laborious process, carefully filling in spaces and trying to make the edges of the washes exactly meet, so that white paper is not left between the edges, and so that edges do not overlap. The rather obvious fact that a dark tone can be painted over a light tone is overlooked.

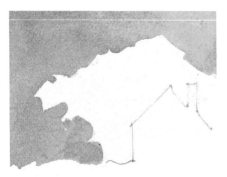 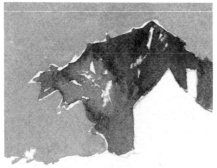 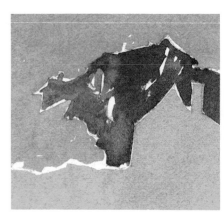

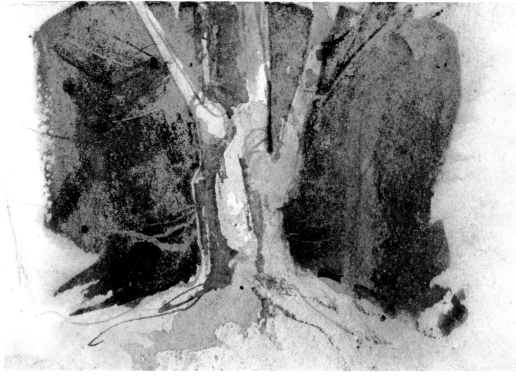

Here a simple tree shape is painted in the same process.

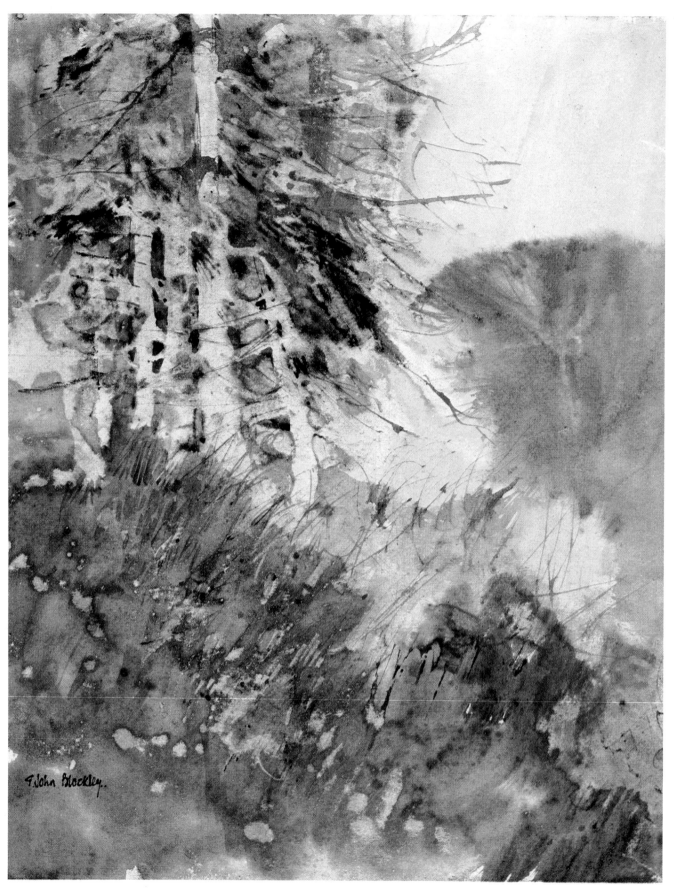

John Blockley.

72

In the painting opposite the dark foliage is used to explain the light trunks.

Above: a reconstruction, showing how the effect was achieved. I began with a wash all over the paper, then the dark background tones were applied, leaving the first wash uncovered as light toned tree trunks.

PART 4 *Picture making*

So far we have been concerned with the mechanics of painting, working with washes, adding colour and lifting colour. We have talked about colour, colour mixing and tone. These are the mechanics of painting and with practice you will learn them. They will become your vocabulary for expressing your personal and unique conceptions. This can be the big adventure, a way of life. Don't be too worried when the techniques go wrong. Preoccupation with technique can stifle individual expression. Painting is not about perfectly executed technique, desirable though this might be. Better an original statement, expressing a unique viewpoint, something to make people think.

In the paintings that follow I show how I use the processes we have been working with. Look again at the beginning of the book and then discover them in the paintings that follow. I have tried to explain my reaction to a scene, what motivated me. It is important to try and realise your reaction to a subject. What aspect of it immediately appealed? Was it colour, light, shapes or what? Try to encapsulate in your mind that particular first reaction. Then think about how to express it. Sometimes in my paintings I will exaggerate a tone, making it, for example, darker than it really was in order to emphasise a light passage that interested me.

In my paintings I try to think largely in abstract terms, of smudges and dots, lines and shapes that suggest rather than state. These areas of the painting have no literal meaning. I regard them as a supporting 'background', building up to specifically chosen features. I invite the viewer to examine the paint surface, and make his own enquiries about it. Then, I positively describe my chosen parts. I try to balance indeterminate, suggestive parts with statements of fact. Equally I want the factual part to legitimise the abstract part. Together, they describe a particular environment, and a particular emotion.

I have extracted some parts of the following paintings and reproduced them same size as the original paintings, so that these qualities may be seen more clearly. You will see that these extracts have some of the qualities of the 'Beginnings'. They are not bits of technique for the sake of technique but are made in the context of the painting and do have meaningful purpose.

Some painters prefer to work in great detail, with every part described, sometimes with minute brush marks. It is necessary to look at all kinds of good paintings. Explore them, and try to see the thinking behind them.

So, we have looked at the basic processes of traditional watercolours. The big adventure is to come. You will start to look and think as a painter. Gradually, out of a confusion of styles your own way of working will evolve. Don't hurry to achieve a style. This is not easy, and you will be intrigued by the ways of many artists, but try to be sincere about what you are painting. Express your thoughts in the way that is most natural for you.

Yorkshire Landscape (opposite)

This is a painting of a favourite place. Not an exact place but a memory of the special lighting that sometimes occurs in these parts of northern England. It is big country with long swells of wind-slapped land and the plaintive call of curlew hanging in the wind. The short, sheep-cropped grass barely covers the white limestone ground and under certain lighting it is crossed with ribbons of intense brightness. This intensity of light is frequently sharpened by a deep blue-black sky, and by land curtained by cloud to a deep velvet tone.

I have tried to distil my thinking to the essentials—blue-black sky, velvet rich foreground and the band of distant light landscape.

I noticed that the sky, though mostly dry, was spotted at the top with still wet paint. I washed this off under the tap, to produce the light mottling as a little relief to the dark sky. Otherwise, the painting was done with considered economy.

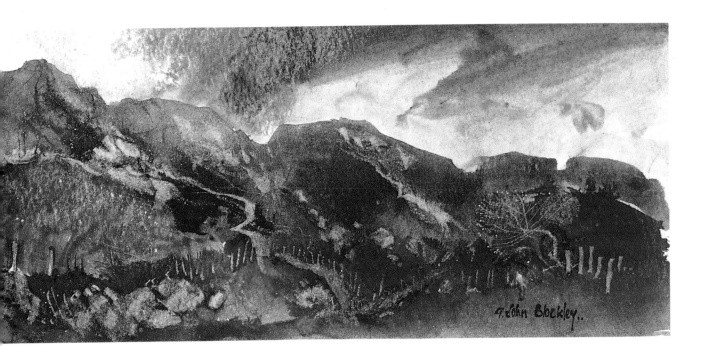

Pembrokeshire (above)

A small watercolour painted on a cold blustery evening, sitting on a rock in the shelter of a stone wall for about twenty to thirty minutes.

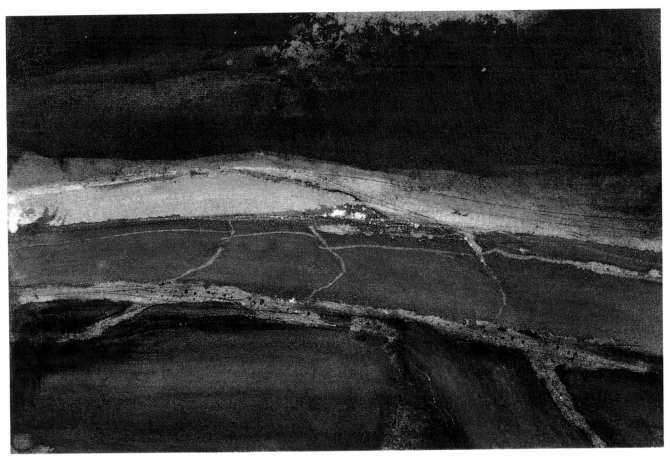

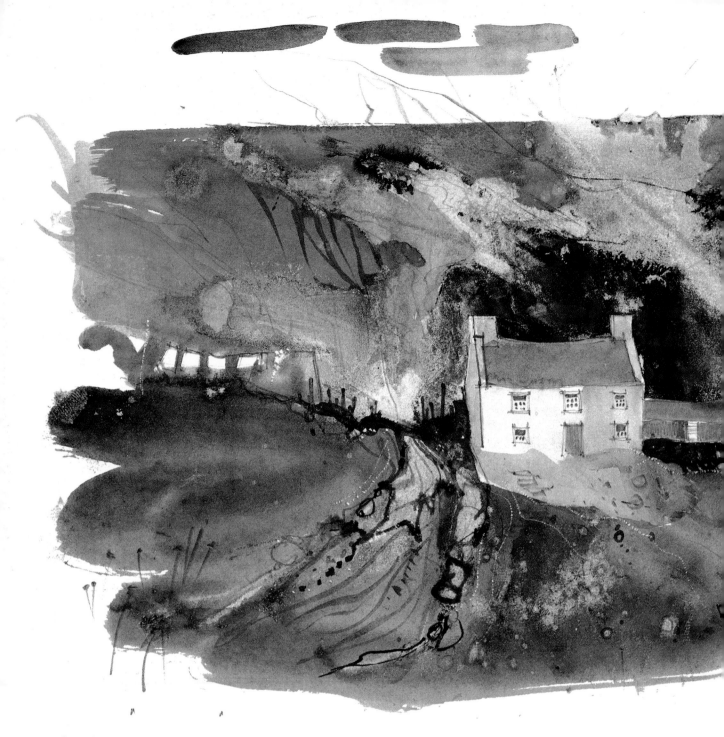

Sketches

Drawing consists of lines, smudges, dots or any mark that will explain the qualities felt about something seen. A drawing may be made purely for its own sake—as a piece of artwork in its own right. There are many examples by past and present masters that should be studied. They can be economical—fleeting expressive lines with variations of thickness that express volume and form, or they might be extensively rendered in line, tone, and colour.

Occasionally, I will sit for some time to make a considered and careful drawing. This requires accurate comparison of dimensions, judging the height of one object against another, and its placing, above, below or level with other objects. Unless these measurements are judged correctly, control will be completely lost, with objects out of scale and out of place.

Mostly, I sketch for information. Very often the sketches are slight, and almost reduced to shorthand notes. I find that the action of making even these brief notes calls for intense observation which is enough to

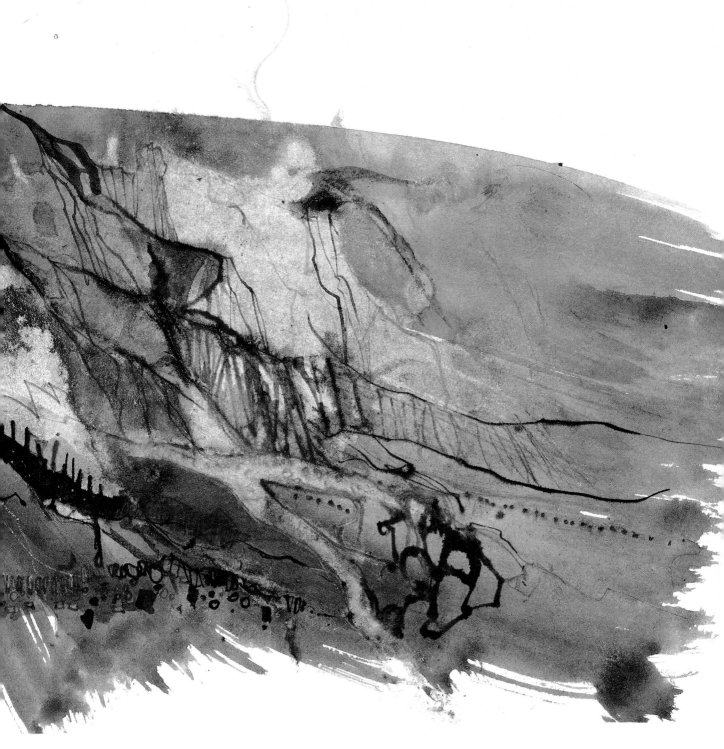

Under Snowdon

stimulate my memory when I come to paint at a later time.

For line work I use mostly a 2B pencil, black or coloured felt-tipped pens, pointed and of various thicknesses. There are chisel-like felt pens that are useful for 'slabs of colour. Broad lines can be made with sticks of graphite, coated with plastic covering to keep the fingers clean.

I sketched this hurriedly, with sketch book resting on the car, in a narrow road, busy with traffic.

Pencil and inkwork was used and while some of the ink drawing was still wet I brushed watercolour into it. The drawing is rough and crude but expresses my response to the place—a feeling of ruggedness and texture, and of wide tonal range, from light to black. The crude colour notes are sufficient for me to recall when I come to paint from the sketch book in the studio.

77

Bradley
Coverdale.
Yorkshire

ER

POST OFFICE
ER

Red
Pen

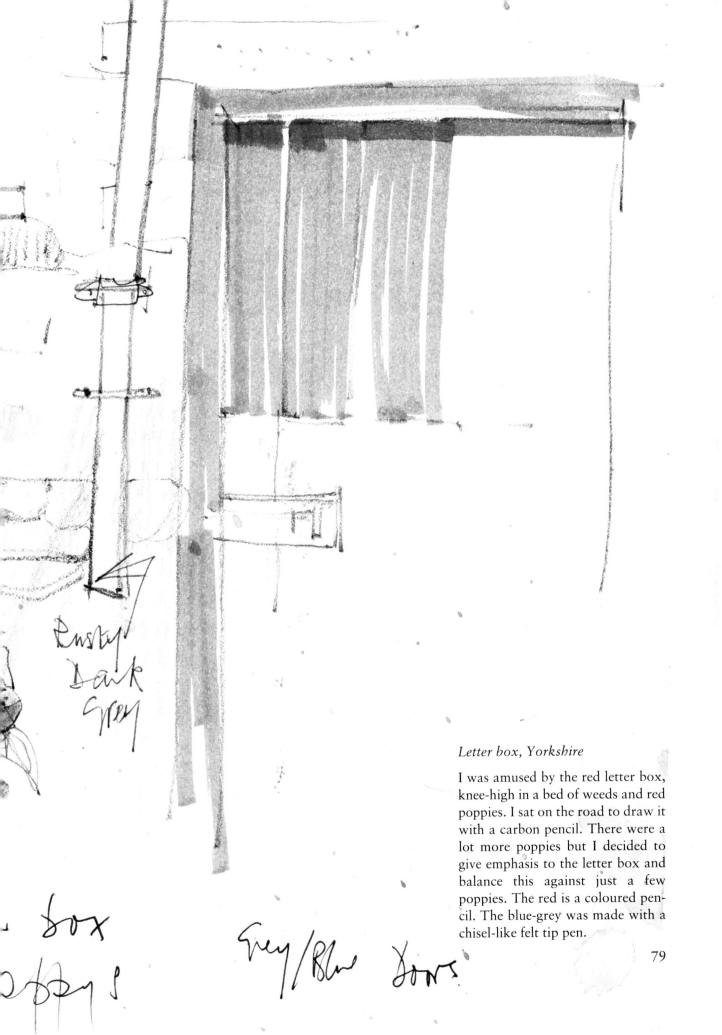

Rusty
Dark
Grey

Letter box, Yorkshire

I was amused by the red letter box, knee-high in a bed of weeds and red poppies. I sat on the road to draw it with a carbon pencil. There were a lot more poppies but I decided to give emphasis to the letter box and balance this against just a few poppies. The red is a coloured pencil. The blue-grey was made with a chisel-like felt tip pen.

box
ppys

Grey/Blue doors

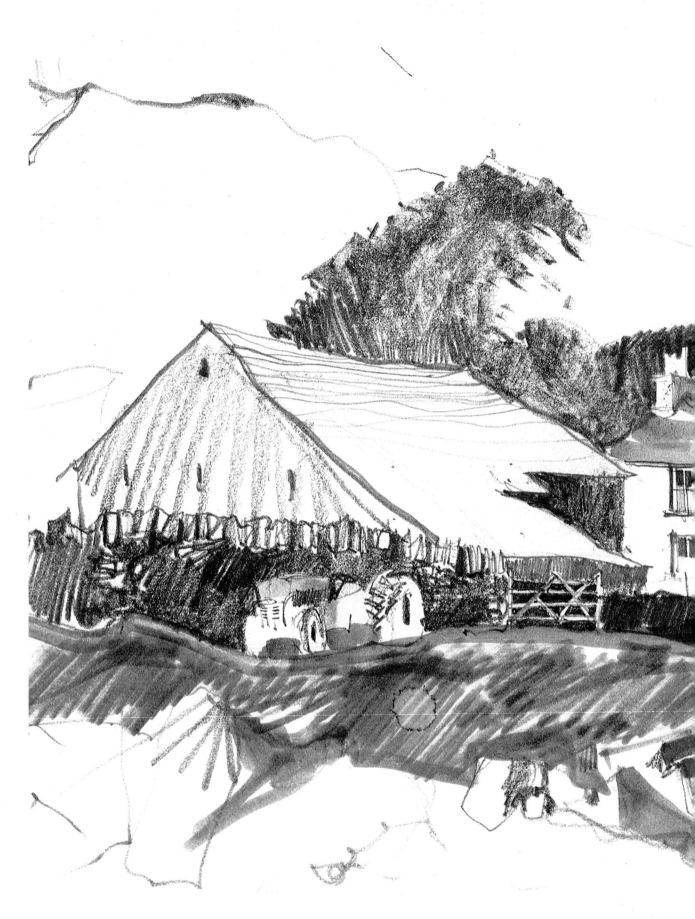

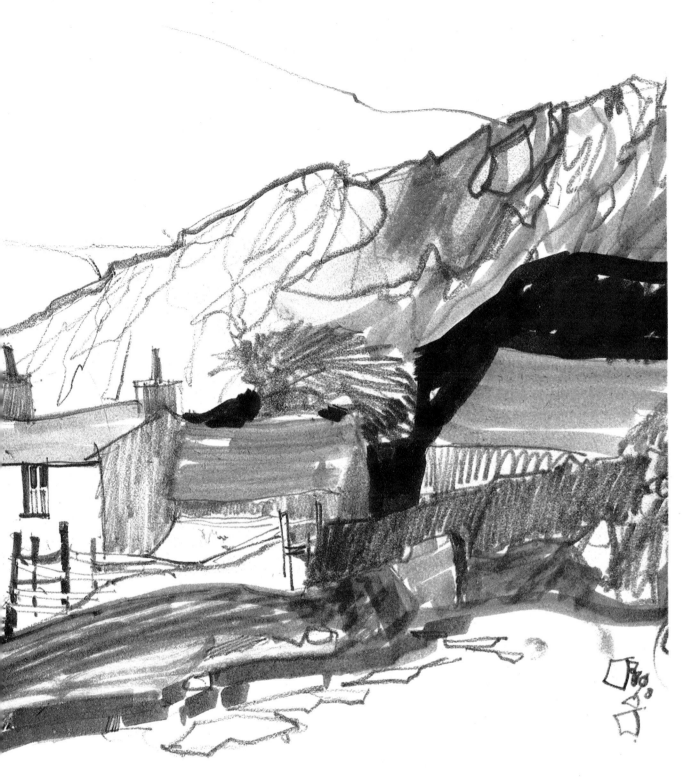

Cottage : Pinky White.

Barn : Sludgy green.

Near Broughton, Cumbria

This is a detail from a large sketch which stretched 46 inches long across two pages of a sketch book. The cottage is drawn fairly accurately with proportions carefully observed. The rest of the drawing was slashed on to the paper using carbon pencil, black, grey and green felt tip pens.

Estuary sky

Depressed with a period of unsuccessful painting, I painted this quickly and with a kind of spurious bravado. Speed is not a necessary requirement in painting, but sometimes it gives a freedom of expression and a means of loosening up that is helpful. When working in this way, colour is picked up from the paint box almost instinctively and cannot be exactly recalled. Looking at the painting now, the sky suggests a first wash of cerulean blue, possibly slightly greyed with the accumulation of dried paint in the paint box lid. I always carefully clean the mixing well in my box, but never the lid, so that the encrusted build-up provides a useful source of neutral greying pigment. I am sure that this is a dirty practice not to be recommended. My explanation is that I use only very small amounts so that the wash stays clean. With this wash still damp, the clouds are brushed in vigorously with diagonal strokes of indigo mixed with Paynes grey. There is a hint of green in the clouds, suggesting the use of a touch of left over green from the paint box lid.

Brush strokes were also made across the damp lower half of the paper, not caring, or perhaps thankful, that some of it unintentionally bled into the sky. Later, with the paper dry, a suspicion of hard-edged headland was added along the horizon.

I think perhaps the painting does contain a sensation of mood and atmosphere. It is about the sense of a situation, not about detailed representation, and was painted in the attitude of the 'beginnings' discussed earlier in the book although on a larger scale and taken to completion.

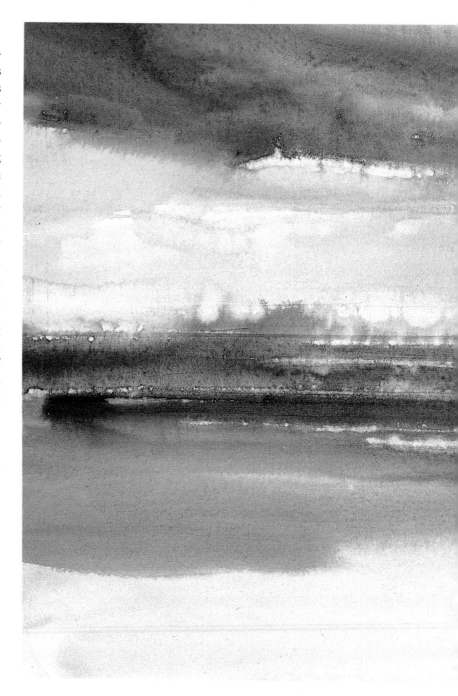

The painting was started with a reasonably clear intention—to paint an effect once seen and remembered with some intensity.

Often, a painting is made in clinically thought out stages. Each wash is a precise step towards a calculated result, analytically planned in terms of shapes, balance, colour relationships and so on. It is important to work with discipline, in a controlled manner, and it is meaningless to just throw paint on to paper and hopefully wait for something to happen. But having gained some experience and control of the medium it is stimulating to sometimes 'have a go' and work with the freedom of these 'beginning' paintings.

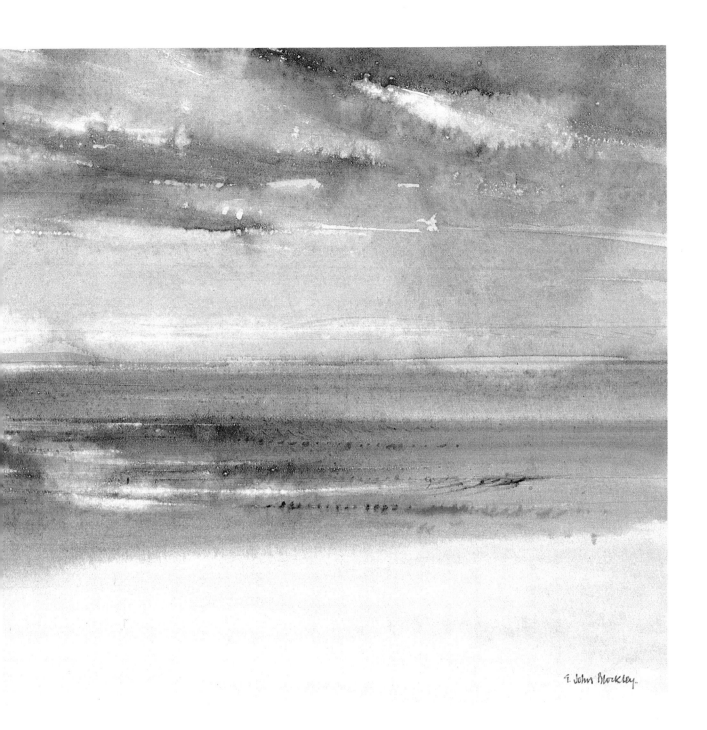

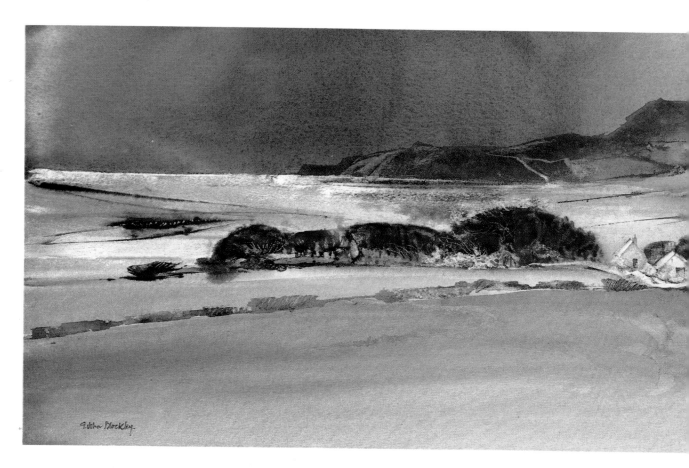

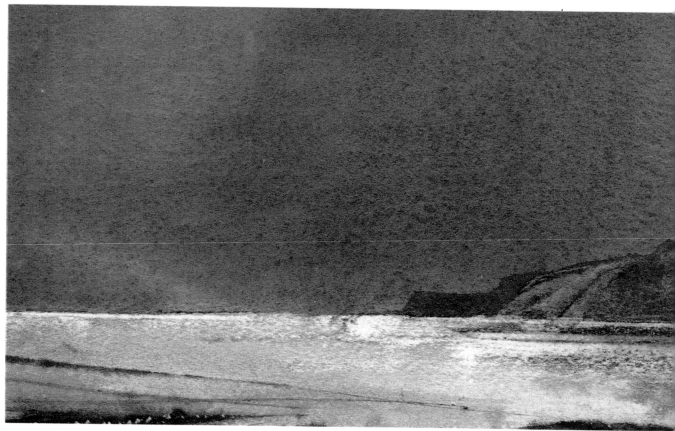

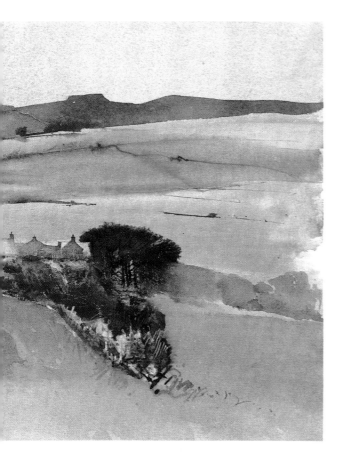

Towards Strumble Head

This was painted mostly on the spot on a very wet day. The rain poured down and I sheltered in my car, jumping out at intervals to paint, resting the painting on the car. The painting was just too big to work inside the car. I took few liberties and painted it as a reasonably true record of the actual scene. Very conveniently the lighting provided a useful distant counterchange of dark and light. The light sea is placed below a dark sky, and the dark mountain is placed against a light sky.

The tops of the trees contain echoing curves, repeated again in the small group to the right of the buildings. Two of the buildings also make echoing shapes and I expect I cheated a bit in painting them so. The diagonal direction of the trees below the houses provide sufficient relief to all the horizontal directions in this longish painting. I was careful not to extend the trees to the corner of the painting. The hedge on the left also introduces a slightly sloping element into the painting. I purposely painted it lighter than it actually was so that the darks are contained in the trees.

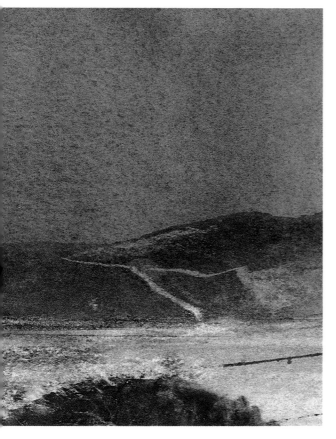

Extract 1 (actual size)

The light on the water is intensified by the contrasting dark sky. To emphasise this I made the horizon sharp and brushed the tones of the water in with an old, worn oil painter's hog brush using horizontal strokes across the texture of the paper. When painting the first washes of the landscape I was careful to preserve the white of the paper for the brilliant light on the water.

85

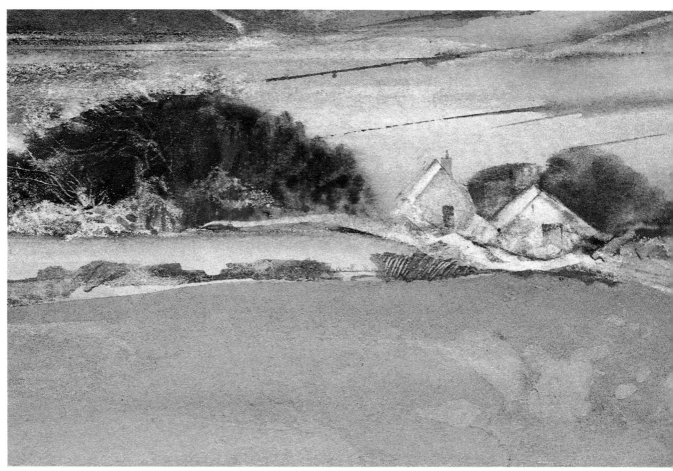

Extract 2

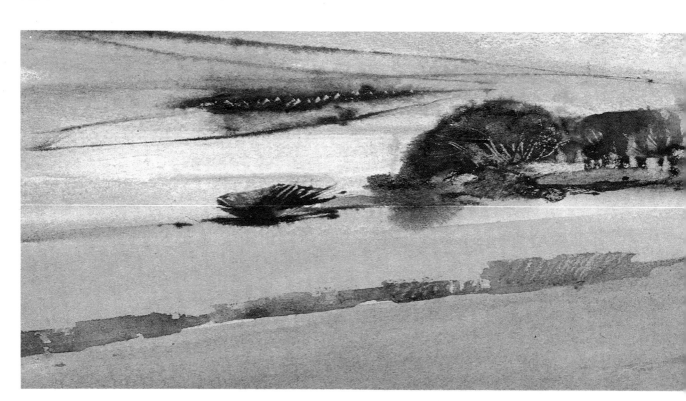

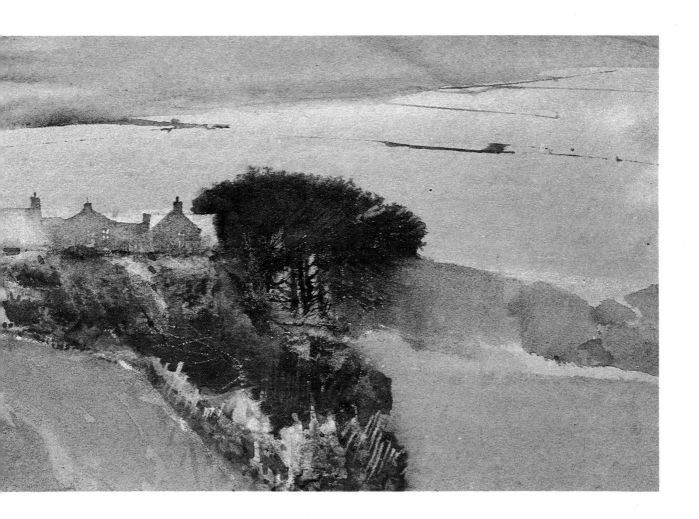

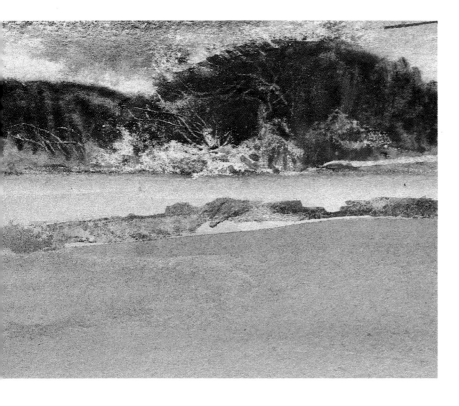

The painting was completed on the spot, except the foreground. At this stage the painting contained all the essential information and so I left the foreground as a first preliminary yellow-green wash to be completed at home. I thought it important not to overload the foreground and to maintain the interest in the upper part of the painting. Back in the studio I merely washed more colour over the foreground and then blotted out the few textured shapes below the buildings. I decided this was enough to relieve the empty foreground.

Extract 3

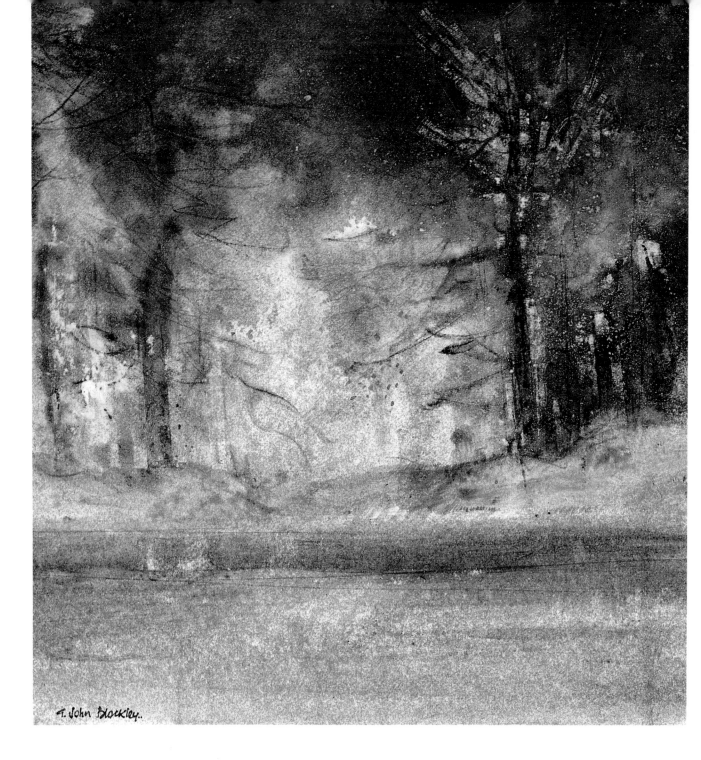

F. John Blockley..

April trees

An early morning, softening the tree forms. I visualised the shaded underside of the tree tops as a dark canopy of sombre grey green that serves to highlight the pale grey distance with its promise of silvery light. The water reflects this light in slightly darker tones and the lower foliage catches sufficient light to hint at the bright green of spring.

The painting began with a very pale wash of Paynes grey mixed with the merest touch of indigo. This wash was taken all over the paper to represent the palest greys of the distance and the water. While this wash was still damp the tree forms and the soft tones of the water were brushed in. By working into damp paper all the tones are soft-edged. As the paper progressively dried I worked in firmer indications of tree forms, but all edges are relatively soft in keeping with the nature and time of the day.

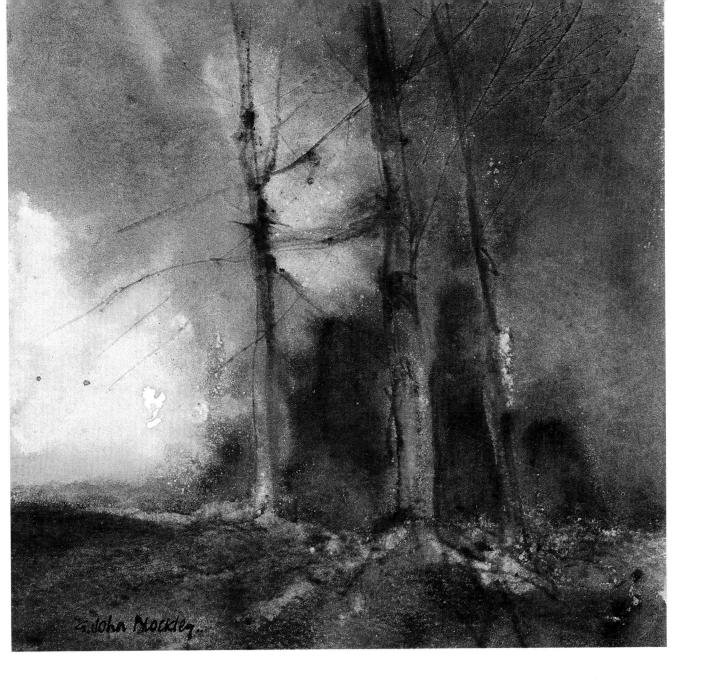

John Mockley.

March trees

March is a favourite month. I am tempted to say my favourite month. Not winter, not yet spring, but with winter colours and expectations of spring.

March is a month of dramatic colouring and tone. I especially enjoy late afternoon with the filigree of bare branches, black against metallic sky.

When painting woodland trees, we sometimes have a paradox in that the trees appear secondary to the colour. The trees we wish to paint lose identity within the overall intensity of colour. Sombre, rich, deep blues, deep reds with here and there clinging remnants of autumn colour.

I have tried to show this in my painting by sketching the trees only slightly, with a pointed stick dipped into moist colour, straight from the watercolour box. I washed varied colour over all the paper and drew the trees into this with my stick to produce a soft indefinite line. The wash, brushed exuberantly over the paper contained wet into wet blendings of very diluted alizarin crimson, just staining the paper for the lighter parts, then full strength alizarin crimson, mixed with a little Paynes grey for the rich red parts, and soft diffusions of indigo and aureolin.

The wet in wet dark tones suggest mysterious woodland depths with indefinable shapes and these dark tones also help to accentuate the clarity of the distant pink.

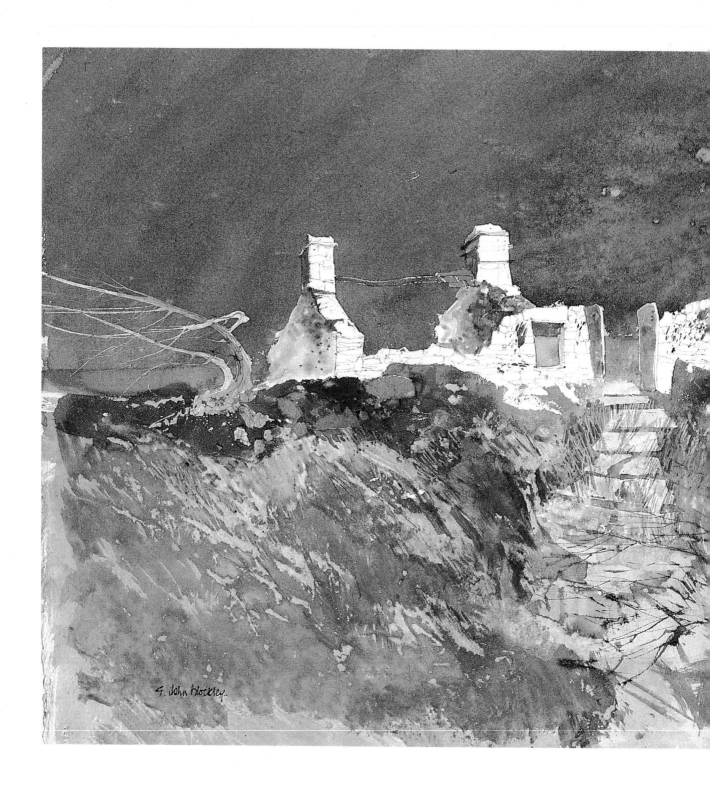

G. John Blockley.

Derelict cottage, North Wales

I was interested in the bleached-white quality of the stonework of this abandoned cottage. This, I emphasised by painting a dark dull-blue sky, but not over-dark. I was quite fussy about this and carefully mixed the wash of mostly pthalo blue with a little indigo and tested it on a trial scrap of paper.

I used this wash for the shaded sides of the building, and used it with a pen to draw fine lines of stonework. I kept the stone footpath exactly where it was, leading vertically through the centre of the painting. I wanted this footpath, leading up to the cottage, but not too evident and this I achieved by crossing it with diagonal brush strokes suggesting grass. I saw the grass as cool green and hatched with dull silver light, dissolving into bigger random dissolving into bigger random blotches of dull light. In the immediate foreground I only hint at an angular spikey bush typical of this rough country.

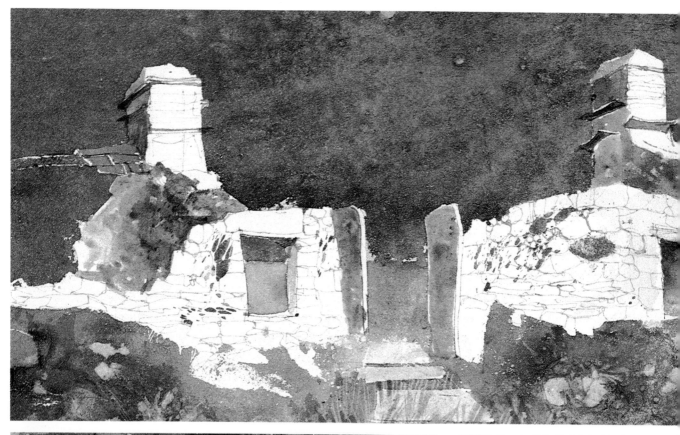

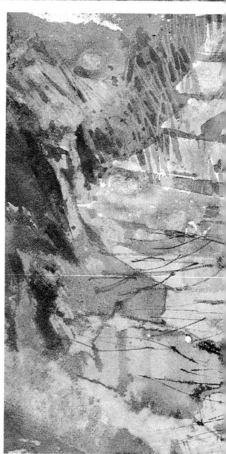

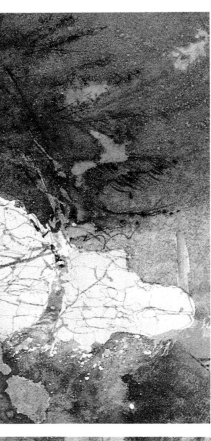

Extracts: these show how the painting surface contains various edge values. Some brush strokes are crisp and edgy, and some soft, giving a balance of precise shapes and insubstantial forms.

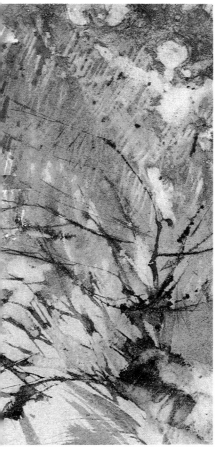

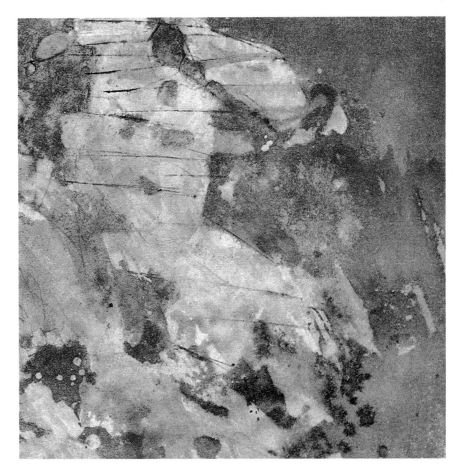

Markham Colliery

The weather had been impossible all morning, raining, cold and grey, in this coal mining valley of South Wales. I cheered up when I saw this exciting subject, and after a chat with the pit manager, sat in the car to sketch.

Usually I make quick sketches to register an impression of the place, enough to stimulate my memory when painting back in the studio. Here, close to the structure, I wanted it to be factual, and structurally correct. I found this quite difficult. The proportions had to be correct, the angles correct. I wanted this for myself, but I also knew that the drawing would be critically examined when I thanked the manager for his co-operation.

I liked the big wheels and all the diagonals, and the gusset plates that joined the girders: the solid darks of the shadows under the platforms, and the slenderness of the cable wires passing over the big wheels.

I concentrated on drawing the big structure. This was my interest and I only indicated the foreground information.

Then the men appeared, to go on shift. I quickly indicated a few, and made some separate figure notes. Aware of their curiosity I chatted with them. I was told that 'a chap down the valley does drawings of the pits, but finished drawings. He sells them at 90 pence apiece.'

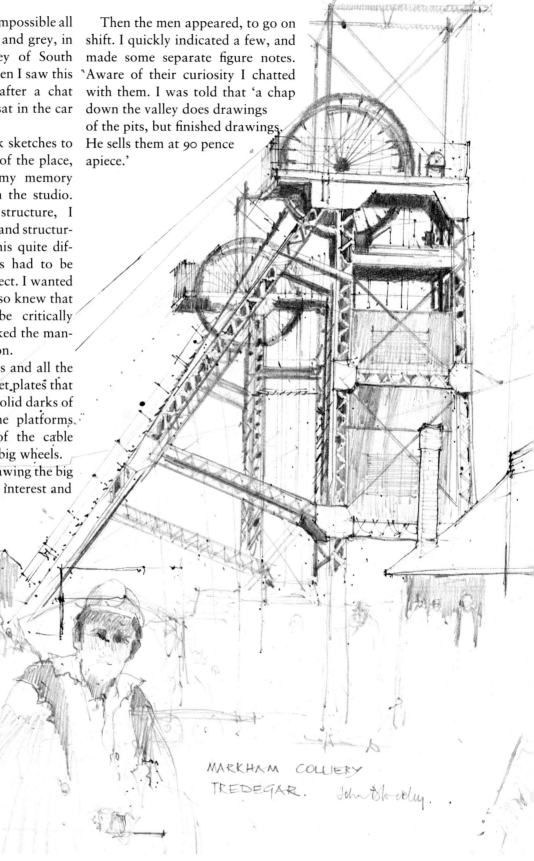

MARKHAM COLLIERY
TREDEGAR. John Blockley.

94

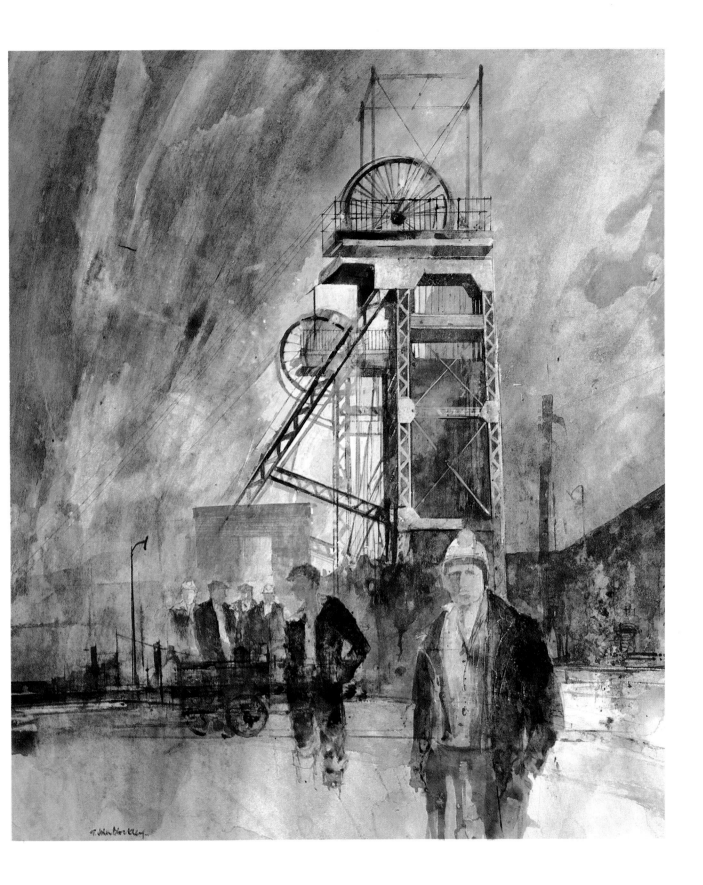

When I came to paint from the sketch, back in the studio, I planned to give the effect of clearing rain, with light breaking through the greyness. I decided to place the light in a descending diagonal movement, behind the big structure and falling on to the square-topped building and the ground. Consequently I painted the building on the right darker in tone. I have tried to give an impression of mysterious shapes, smoke, and hinted background figures.

Parts of the light passage are intensified with washes of very wet gouache. This is an opaque form of watercolour which by dilution with water gives a slightly milky effect. This slight opacity can effectively enhance the translucency of the washes. I deliberately treated the figures in a sketchy manner, so that they integrate with the rest of the painting and are not over-important.

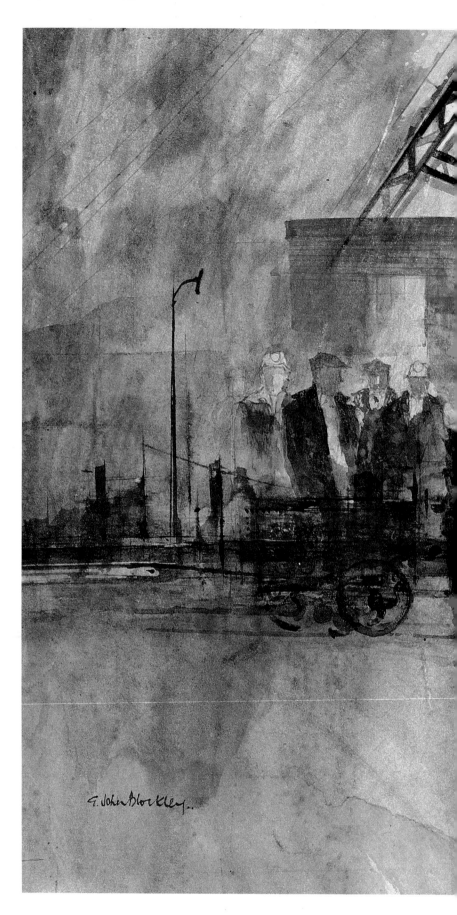

Extract 1

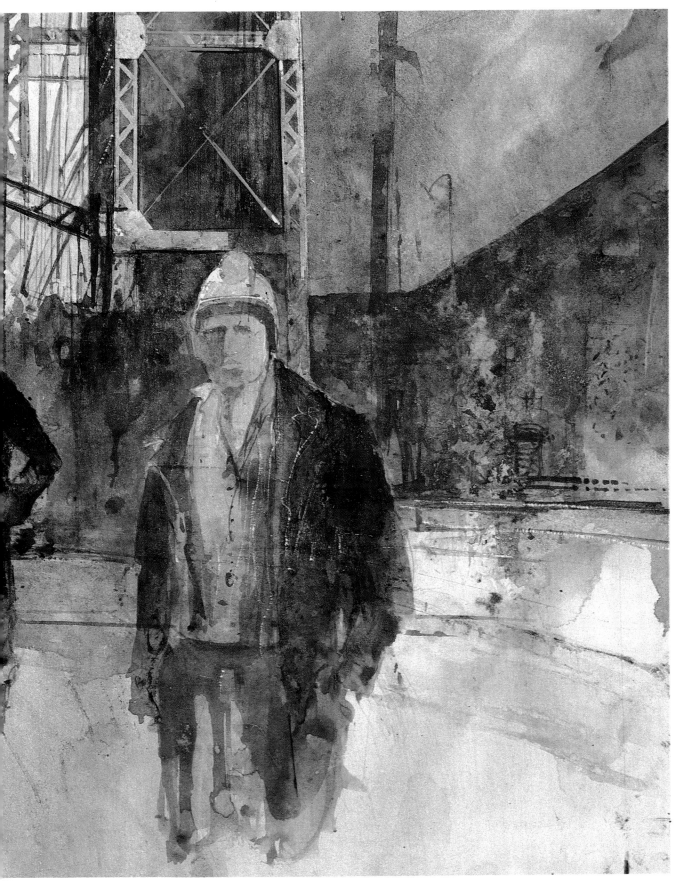

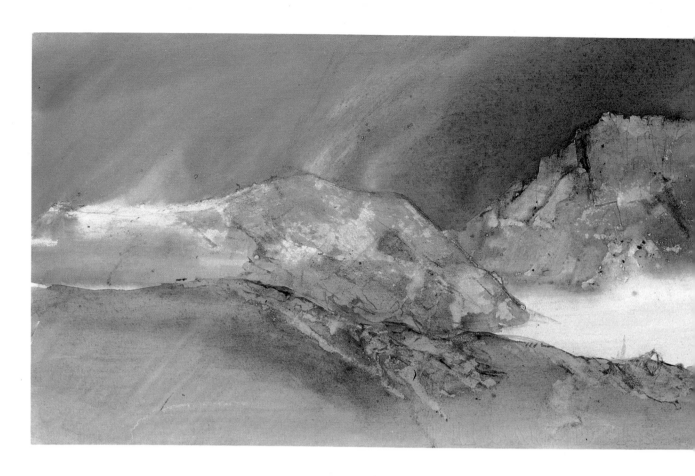

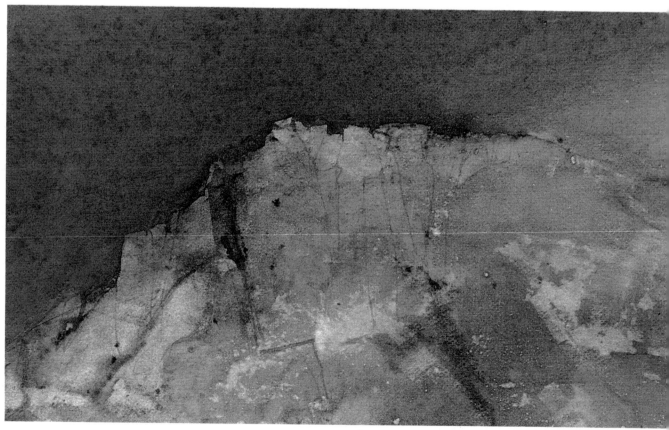

98

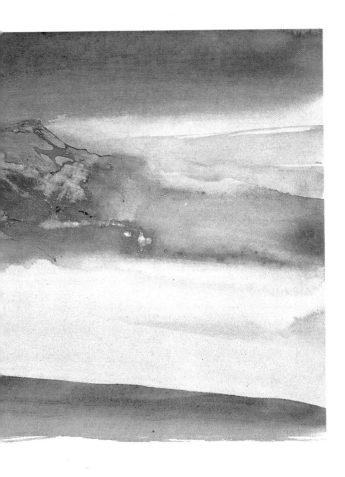

Sutherland mist

I was enchanted by the colouring brought about by the light and atmospheric conditions. I have tried to recall the lustre and sense of vapourising colour and the quality of shifting mist. The painting is not of a mountain, but about a mountain at a particular moment of time.

Extract 1

Most of the painting consists of wet in wet, diffused colour. In places colour was lifted while still damp to give soft-edged lights.

To contrast with this atmospheric treatment, I needed to sharpen up somewhere, to give a little 'bite' and to create a sharp-edged part designed to momentarily arrest the viewer's eye, and then allow it to resume its travels over the painting surface. I chose to locate this edginess in a prominent part, at the mountain top, and near the centre of the painting. This sharpness is made by the dark tone of the sky, painted crisply up to the mountain profile, and by the contrast of dark sky against mountain.

Extract 2

A slightly different treatment is introduced into the left foreground. With raw umber, a warm colour relative to the blues, I drew meandering soft lines to give just a hint of drawing within soft blotted out patches. This was done with a fine brush, into paper *tending* to wetness rather than dampness, so that the line of colour sank softly into the paper surface and simultaneously spread delicately into the surrounding wet area. This method of drawing adds a little stiffness, or substance to the otherwise softly mottled areas, and gives almost imperceptible form, within the overall softness of the painting.

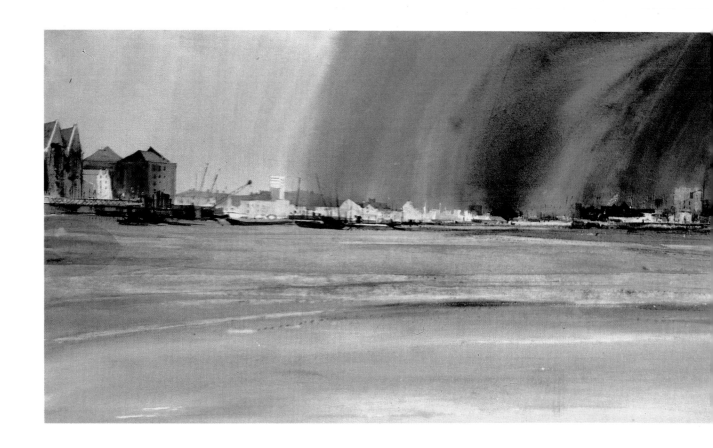

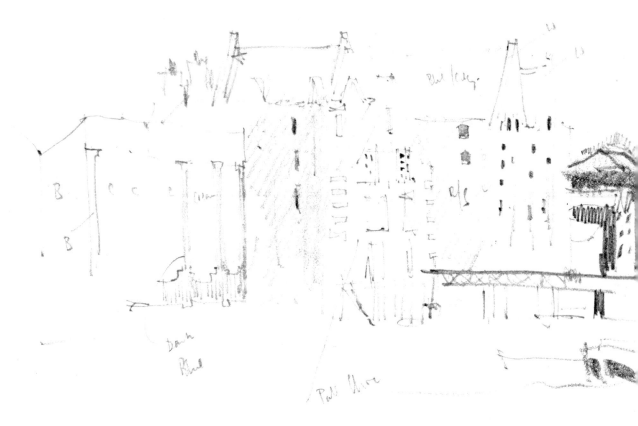

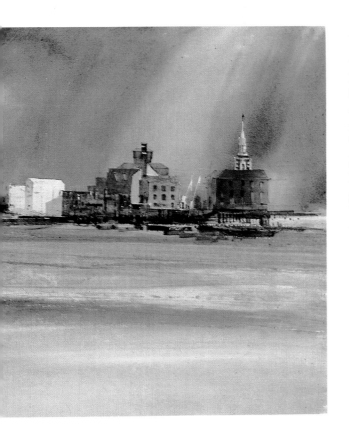

River Thames from Cherry Pier

A cold day with rain falling in the distance but with passages of light intermittently highlighting some buildings, making them brilliant white. These weather conditions appeal to me, indigo sky with impending rain, or raining, accompanied by sudden bursts of light. Transitory and tantalising. I spent some time looking hard, excited but agitated. The visual memory of it will last, but I made a slight sketch quickly, to register the general sense of the river panorama. Some of the buildings were selectively drawn reasonably accurately, while elsewhere I drew only profiles to describe the skyline.

In my painting, I think of the buildings almost as a string of beads, taut across the paper, some glinting with light, and some shaded. The downward sweeps of the dark sky are a foil to the horizontal format of the painting.

Part of the sketch: most of the warehouse buildings on the left were not included in the final painting.

103

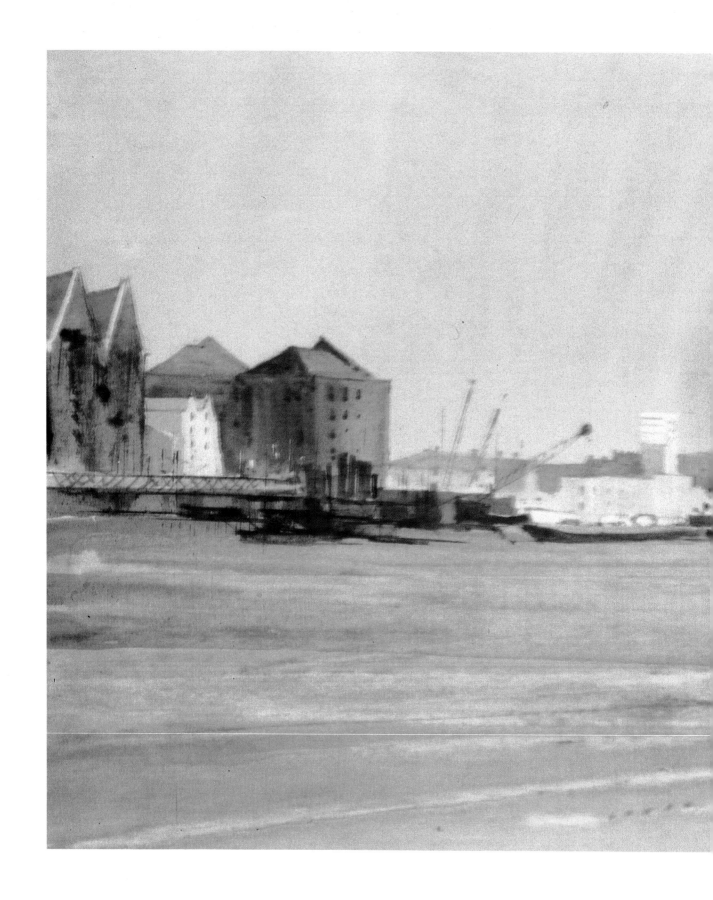

Extract 1 (actual size)

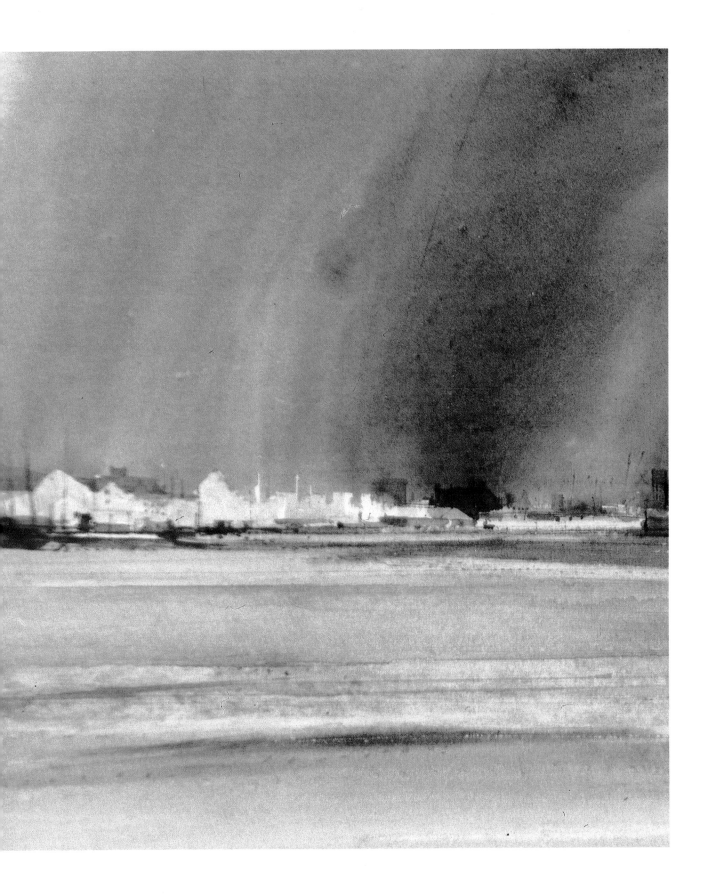

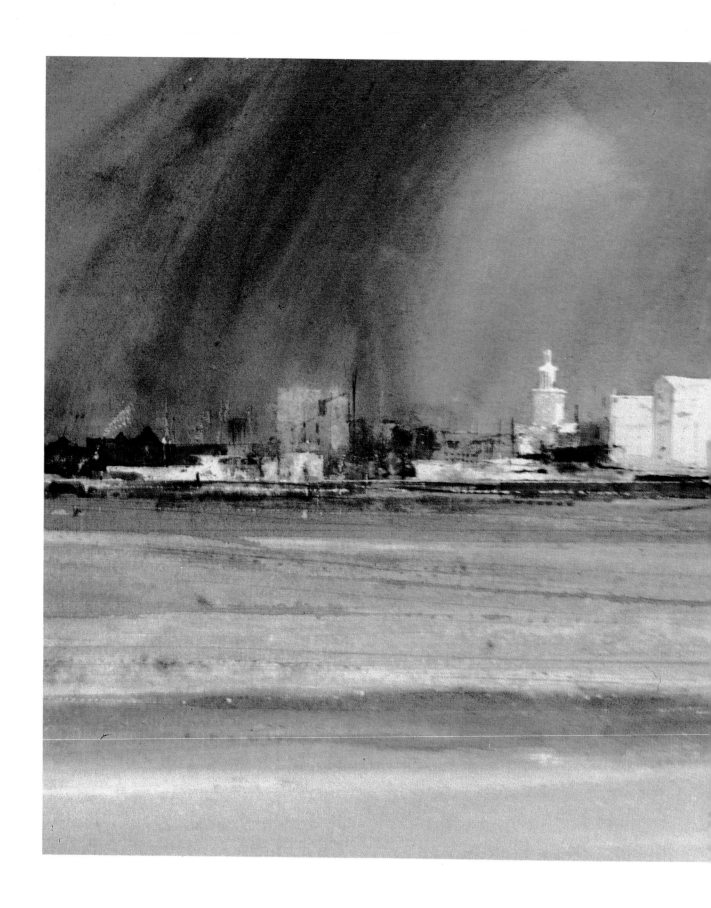

Extract 2 (actual size)

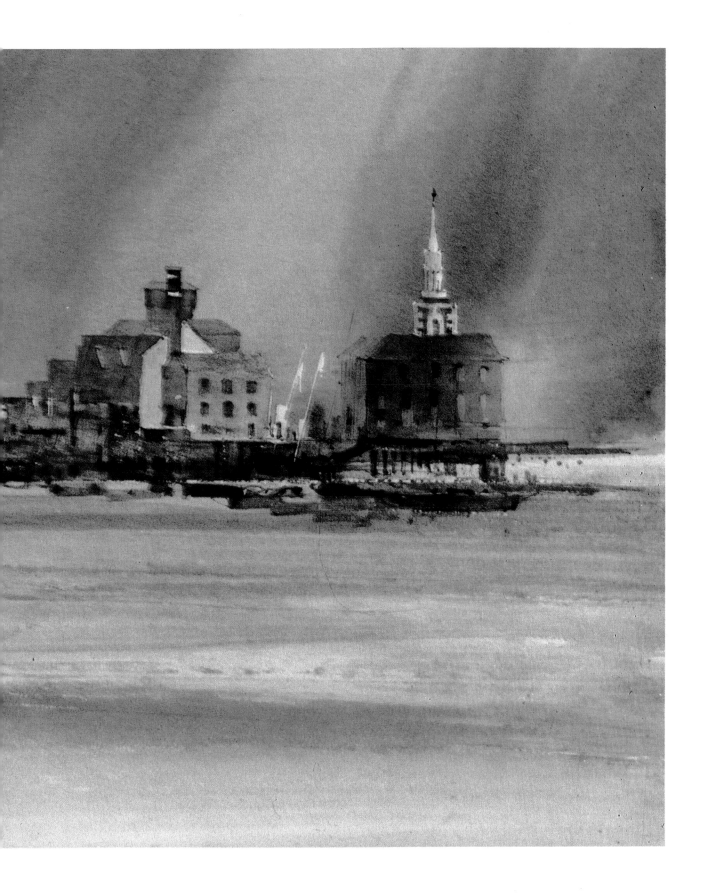

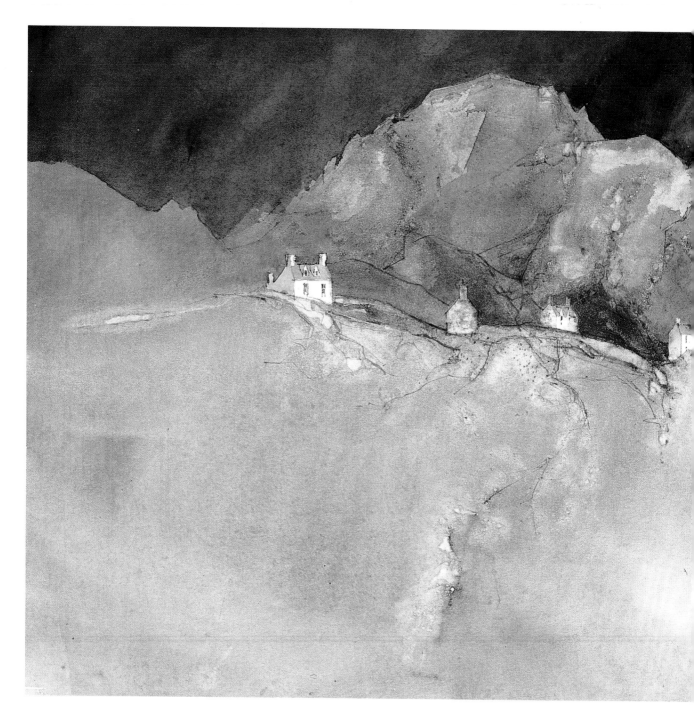

Road to Achlyness, Sutherland

I saw these cottages from across a valley. They sat along a roadside from which the ground sloped steeply towards me. The landscape in these parts is very textured, strongly coloured, sometimes in rich umbers and bleached ochres, sometimes almost purple and sometimes pink and silvery greys. These are colours that I particularly enjoy, but here, I was attracted by the unexpected green, bright and clear. This impression is best obtained with fresh washes of colour and minimum brushwork. With my approach decided, I was able to mentally compose the painting into a wet in wet sky and foreground and a sharp-edged mountain containing some texture. Against the mountain, the cottages are simple hard-edged light shapes, with one dark cottage silhouetted against the light sky. This change from light cottages to the one dark cottage provides an interesting

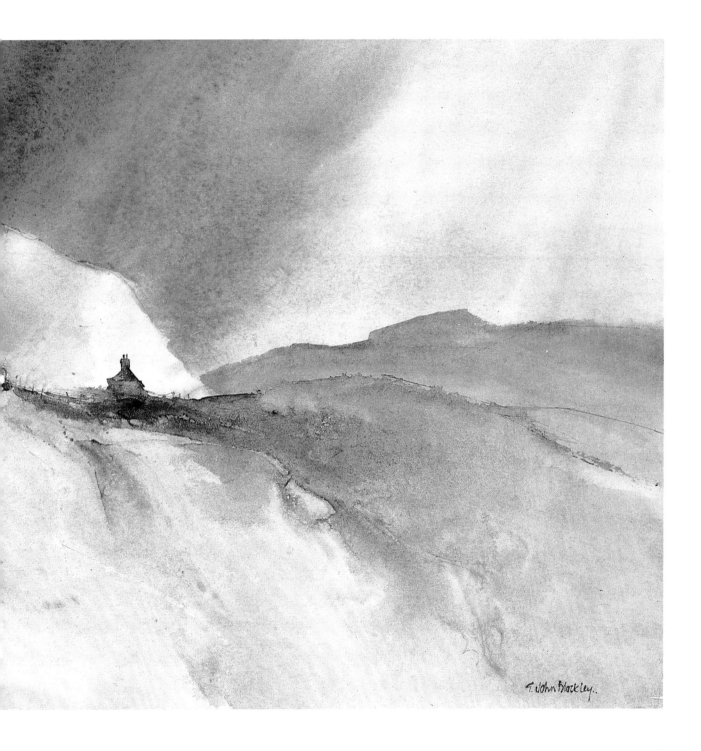

counterchange of tone.

The absence of detail in this light part of the mountain emphasises the impact of the dark cottage and also contributes to the effect of light falling on to the mountain from the sky.

Texture is mainly localised in the relatively small area of mountain, and provides a foil to the general wet in wet atmospheric sense of the painting.

I used Paynes grey with the merest addition of indigo for the sky, aureolin yellow mixed with varying amounts of Paynes grey for the greens, and Paynes grey with only a hint of cadmium red in the dark strip joining the cottages. So mainly, only two colours are used, Paynes grey and aureolin.

Winter landscape

This is painted on smooth hot pressed paper. The painting started with the palest wash of indigo mixed with just a hint of cadmium red, all over the paper. In places, and particularly in the sky, the wash is so dilute it is only just visible and on the smooth paper surface has a slightly marbled effect. This marbled wash is slightly darker in the distant hillside as a preliminary to further strengthening washes later on.

The sky is Naples yellow. This colour has a slight opacity and an almost milky quality. I washed it all over the sky, and moments later I blotted out white patches with newspaper torn to roughly triangular shapes. I let the paper dry then rewet it but left random dry patches in the hillside. Then I painted the strengthening brush strokes of indigo and cadmium red into the wet parts to give soft edges, and left the dry parts as white paper. My purpose throughout was to pattern the paper with random patches of white and colour, some hard, some soft-edged. I wanted varying degrees of softness, with edges disappearing and reappearing and the colour patches losing and finding colour, and veined in places with translucent lines of colour.

The trees were painted with a flat brush 1 inch wide in vertical downward strokes, starting at the top of the trees to determine their curved, crisp profiles.

Below the trees I stroked indigo and mostly cadmium red into damp paper to produce the soft-edged warmer foreground tone.

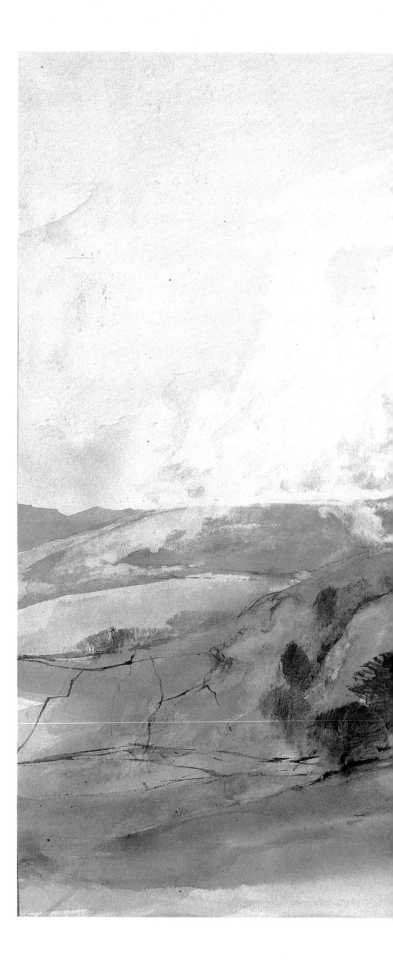

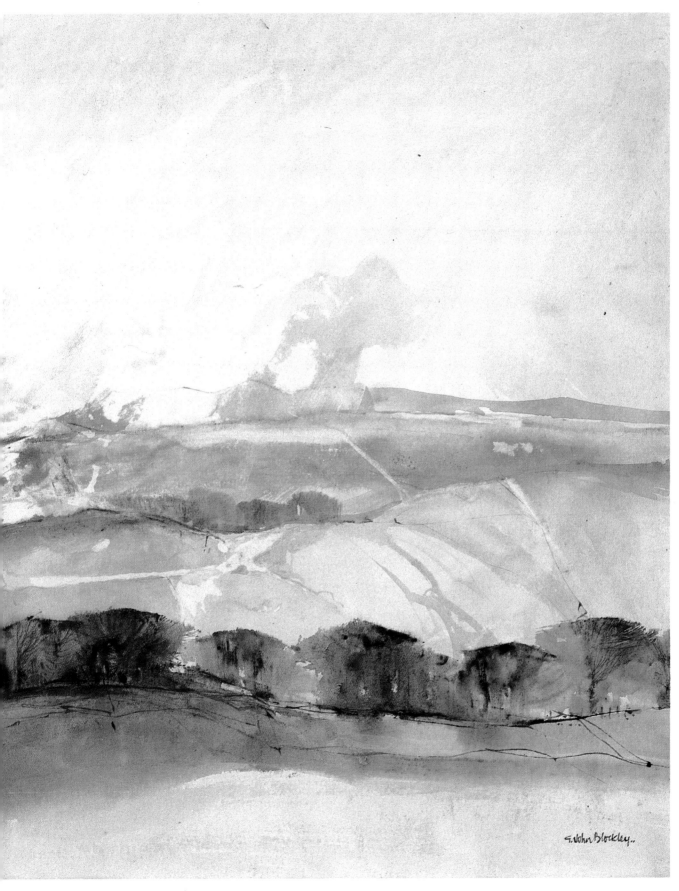

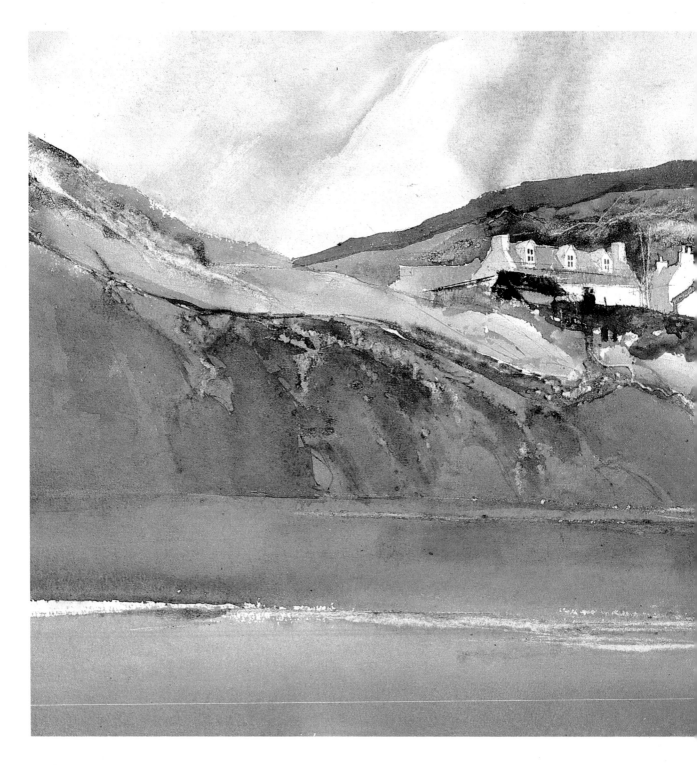

Kinlochbervie

This is a thriving fishing village on the north-west tip of Scotland. The main harbour is just to the left of my painting. Earlier, it had been packed with fishing trawlers, moored side by side. I had been intrigued by the crews arriving at intervals of minutes to take the fleet of ships out to sea. The timing was precise and it was fascinating to watch the procession of colourful ships diminishing to just dark specks as it headed towards the skyline.

I walked away from the main harbour and saw these cottages across the narrow strip of water. The shapes of the cottages, and the shape and textures of the back-

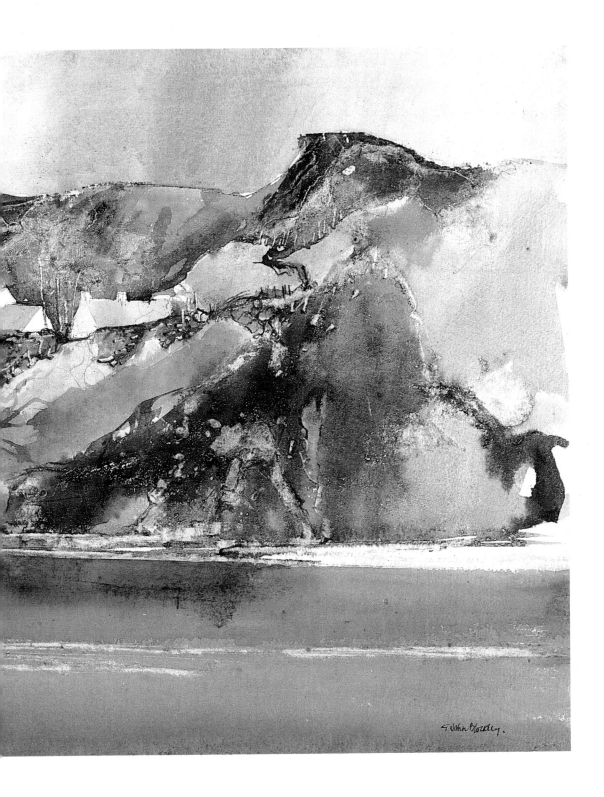

ground hill attracted me. I had felt lethargic, disinclined to work, and irritable at feeling this way in such surroundings. The remedy at such times is to get down to it and start, and quickly involvement takes over.

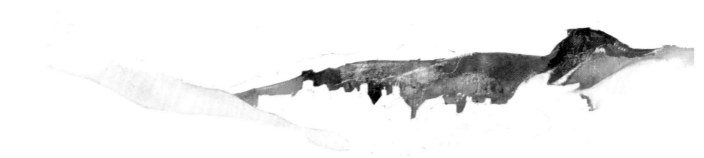

The day was hot, but with a breeze coming across the water creating quick drying conditions, and so I abandoned my normal beginning of washing colour all over the paper. This time, I painted in a sequence of small controlled areas. The problem was to co-ordinate these separate pieces into a satisfactory whole. The solution was to judge tone and colour values accurately and thereby avoid a jumpy busy effect.

1 I lightly outlined the skyline and buildings with pencil. Then I shaped the dark background, around the cottages and blotted the wash to suggest light texture. I used burnt umber mixed with Paynes grey. The yellow strip is aureolin slightly greyed with Paynes grey.

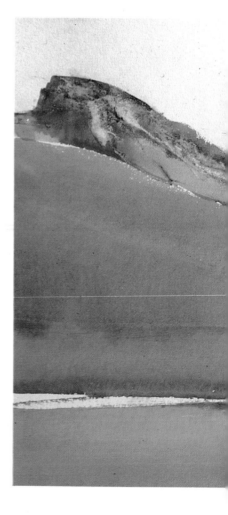

3 I strengthened the painting with further brush strokes into damp paper and blotted colour away with a piece of absorbent paper or rag, to produce textures. The dark greenish tint in the hillside is Paynes grey mixed with aureolin. The water is Paynes grey and indigo, with Paynes grey and cadmium red on the left, and some of the hillside green mixture blended in to reflect the hillside. I completed the painting by further strengthening some of the soft darks, and finally added some simple washes to the buildings.

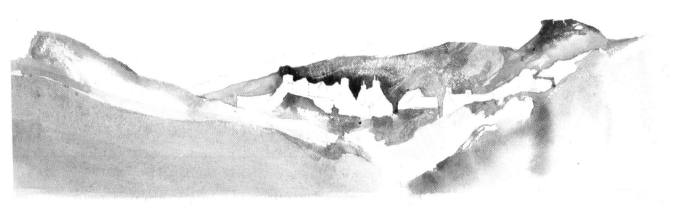

2 The yellow strip had dried. I dampened it with a brush and clean water and added Paynes grey along the top edge. The lower hillside is Paynes grey slightly warmed with cadmium red. While still wet I introduced soft brush strokes of Paynes grey.

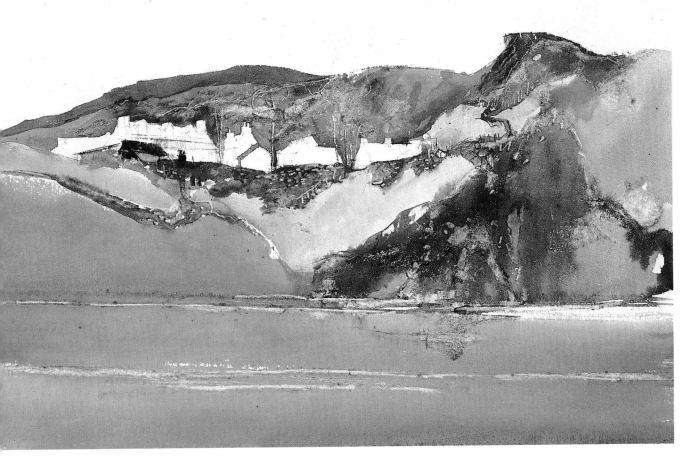

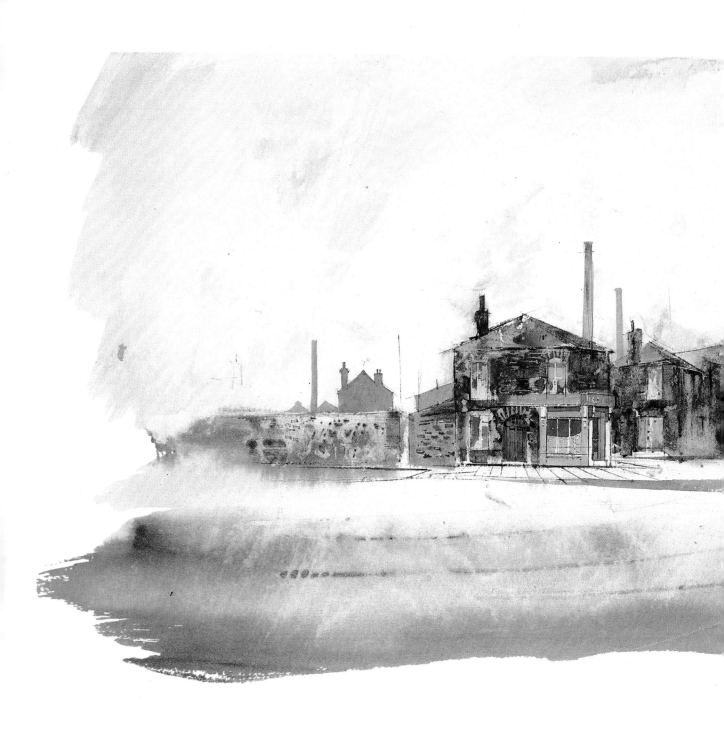

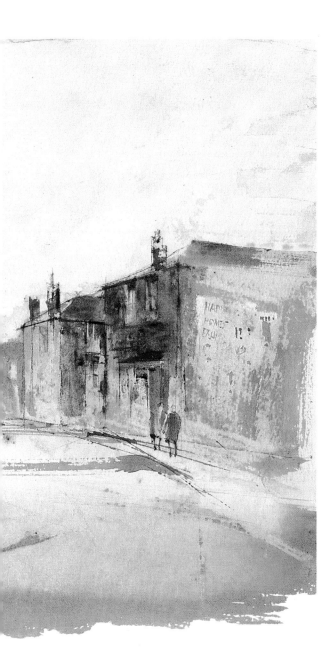

Salford, Manchester

I have spent many hours sketching in this locality, at a time when houses were being demolished in preparation for replacing with blocks of multi-storey houses. Some of the houses were empty, with boarded-up windows and some still occupied with door steps defiantly scrubbed. The houses stood in long rows along cobbled streets. I remember the confines of the narrow streets and the frustration of not being able to stand back far enough to draw, and the slightly apprehensive feeling of intruding on a close community.

The houses were red brick, almost purple, with neighbouring doors in very individual colours, mauve next door to yellow. I recall the city humour addressed to me with my sketch pad and pencil, 'Good morning, Mr Lowry' and 'You the surveyor?'

My painting was made from empty ground, giving me space to stand away and view the few remaining buildings. The painting was made quickly and with a kind of ruthless brushwork which I probably thought was in keeping with the feel of the place. The work shows a roughness of treatment but along with this some precise linework is evident in the buildings. The lines were drawn with pen and watercolour, sliced along the paper to give sharp taut lines in contrast with the roughness. The lines were drawn aggressively, resulting in some carelessness in perspective. This does not worry me, as I was more concerned with conveying the arid quality of this industrial place. I am pleased with the solid 'I'm staying here' quality of the central building, and the sulphurous bronchial sky, expressed in broken strokes and dabs of colour erupting upwards. I am also pleased with the passage of light ground in front of the buildings softening into warm sweeps of tone in the immediate foreground. I quickly skidded the brush over the damp paper to suggest a wide arc of motor-tyre marks sweeping across the open ground.

The house on the extreme right slopes excessively steeply, but I am not unduly worried about this. The painting is sketchy in places, but conveys my feelings of the place.

I remember the advertisements pasted on the end house. These are suggested here as a ragged white shape of paper, and in the original painting I can just read the wording 'Happy Homes Exhibition'.

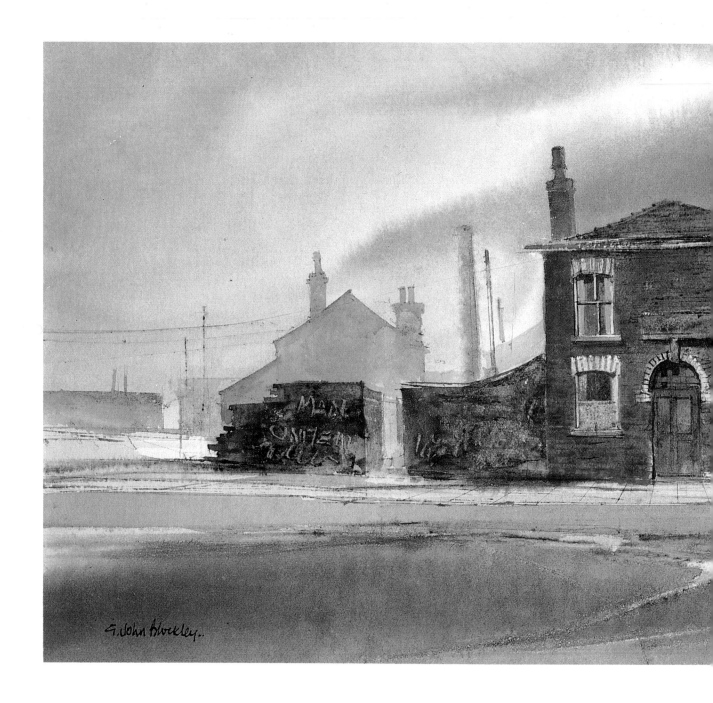

Salford 2

This painting shows the area sometime later with more buildings removed, but my favourite central building still remains. Being nearer, the details of the building are clearer, contrasting with the distance painted wet into wet to give atmospheric effect. The light on the road at the right of the building is soft, suffused and the sky glows from the distant city lights. The painting processes here are technically correct and more carefully executed, but the previous painting appeals to me more in suggesting my personal experiences of the place.

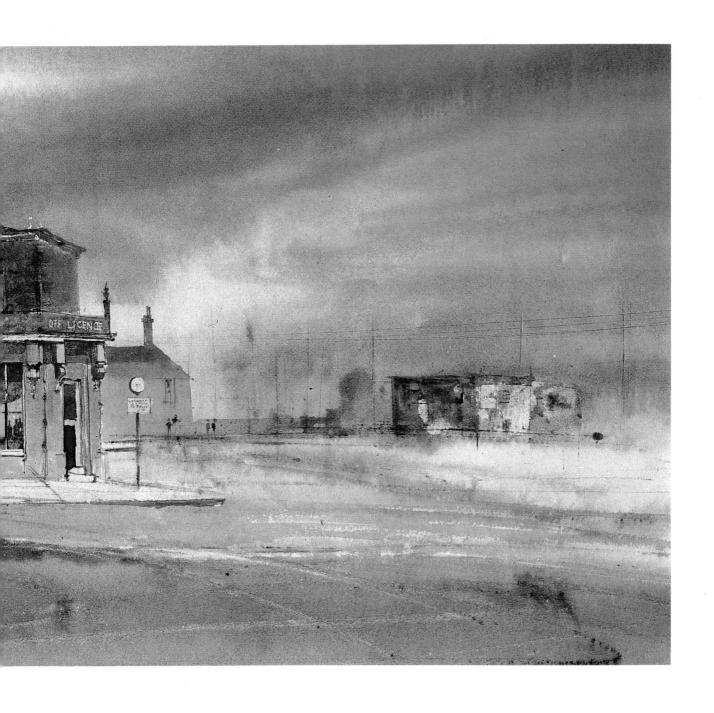

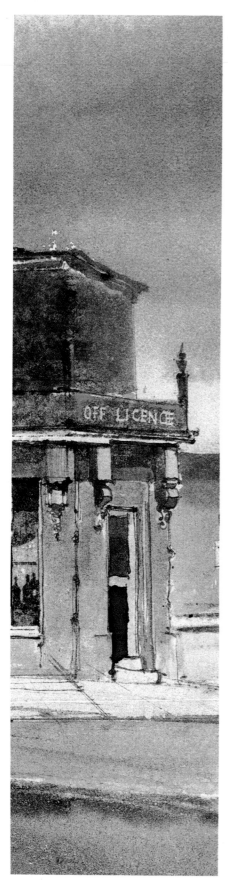

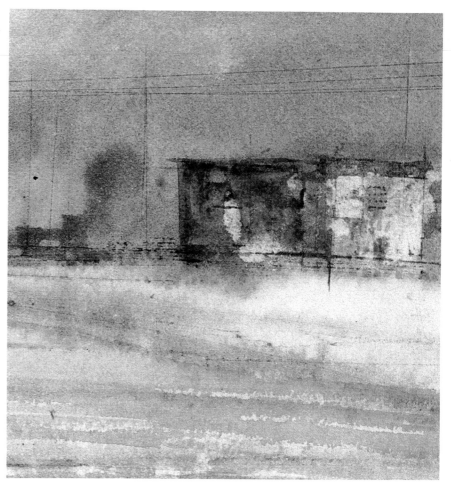

There were a number of these off licence houses in this vicinity, many of them with interesting doorways, complete with carved mouldings and painted timber scrolls and finials. These buildings often stood at the junction of two streets, the corner of the building being built at an angle to position the door conveniently for access from either street.

The scale of my painting can only allow an indication of such detail. I used pen and watercolour (I feed the pen with a brush charged with watercolour) to draw detail. The words 'OFF LICENCE' were drawn with a pen and masking fluid—'Maskit' in USA. This is a rubber solution which is drawn or painted onto the paper, allowed to dry, and painted over. The masking is then rubbed away with the finger to reveal white paper. This is the only occasion I have used it in this book. I have used it frequently in the past, until I thought it was becoming too much of a crutch to rely on, and so I made a deliberate decision to work without it. I have no quarrel with the stuff—used judiciously it can be effective. It is just a personal whim to get along without it.

In contrast with the solid mass of the building I treated the distance as if it were out of focus, with shapes suggestive of buildings, and colours hinting at distant city lighting and advertising hoardings. I have sliced taut pen-drawn lines to suggest, perhaps, telegraph poles and wires. All I wanted was to infer some colourful activity and life, using wet in wet painting to obtain the blurred soft smudges.

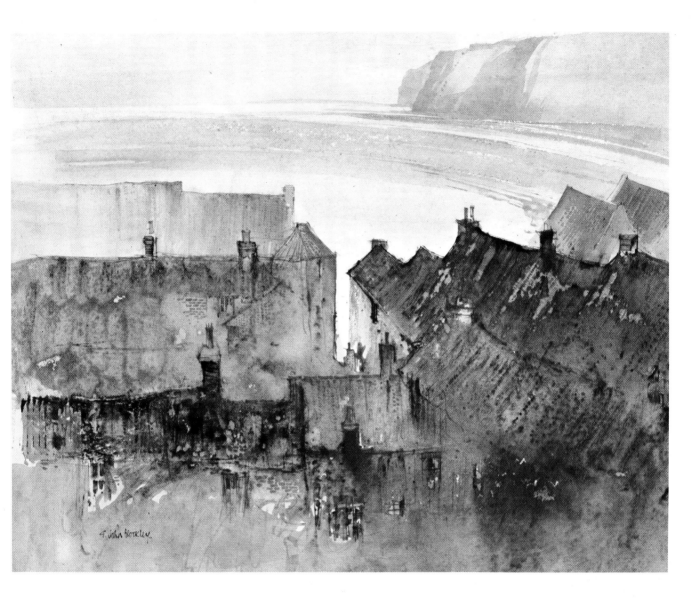

Staithes, Yorkshire

This old fishing village is built on steep cliffs on the Yorkshire coast and the cottages cluster together with footpaths and steps descending and twisting through them. This is a view looking down on the roof tops and chimneys, with a vertical 'slotted' peep through to the sea. All the roofs are clad with lovely old pantiles, vermilion coloured and stained with greys and greens.

I saw the houses as a mass with individual features here and there. Accordingly the whole area occupied by the cottages was covered with one wash shaped to the profile of the roof tops and chimneys. Then I strengthened the wash in places with further washes, and drew into it with a brush, lifting colour, and adding colour, aiming all the time to keep it as one homogeneous mass within which windows and chimneys give the impression of a cluster of many buildings. I wanted the eye

to travel freely over the mass of buildings, and to be arrested occasionally by a hint of detail. I didn't want to paint a number of individual houses, separately one at a time.

The building mass was painted directly onto dry white paper. When this wash had dried, the sea was painted with one pale wash and then overpainted with darker tones, leaving the first wash uncovered behind the buildings. The diagonal direction of the roof tops leads the eye towards this important area.

This pale area of sea provides the main impact and all my efforts were concentrated on achieving this. It is enclosed within the darker tones of the sea and the building and is an interesting shape, especially where it is slotted between the narrow, vertical buildings.

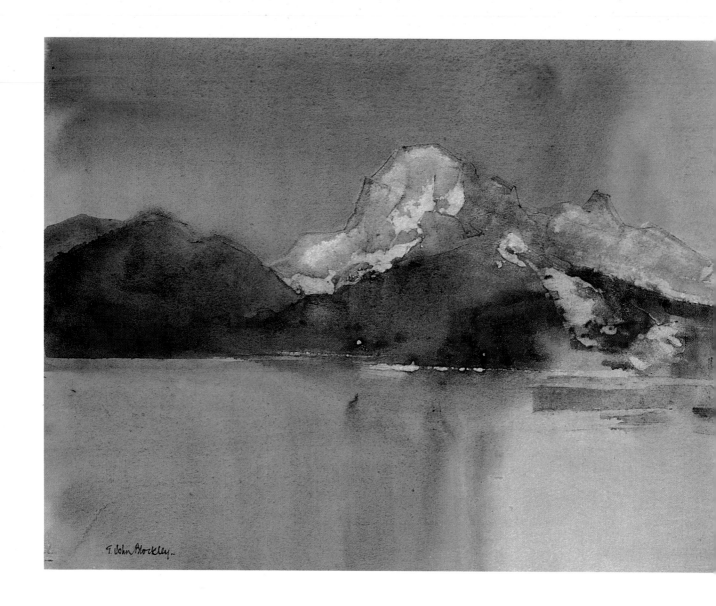

Sutherland, North-west Scotland

This painting relies very much on the simple handling of
a first wash brushed over all the painting. Downwards
strokes in the sky, and the reflections of the water are
brushed into this first overall wash. So far the moun-
tains are ignored. Then, with the paper still damp, the
mountains are added. On the left, the mountains are
indicated mainly with a slight, but decisive outline with
pen and watercolour. On the right, some cobalt violet is
fed into the damp wash, giving a touch of colour.

Finally, warmer colour is painted into the damp
paper for the middle distance mountains.

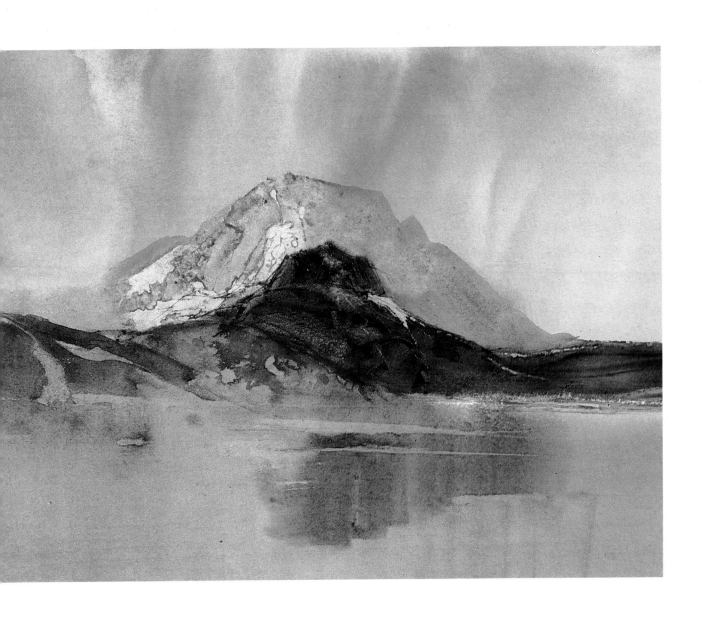

Extract 1 (actual size)

These extracts give further examples of wet in wet painting, colour lifting, and suggestions of drawing. These are all marks of various kinds which are appropriate to this particular landscape. They are designed to provide secondary interest within large areas of the painting and as support to the main areas of interest. I am concerned with emphatically stating certain parts of a painting with hard edges, maximum tonal contrast, and with 'losing and finding' the edges. These points of emphasis are supported by the large non-literal areas of dots, smudges, traces of colour, nervous flicks, soft lights and darks.

Extract 2

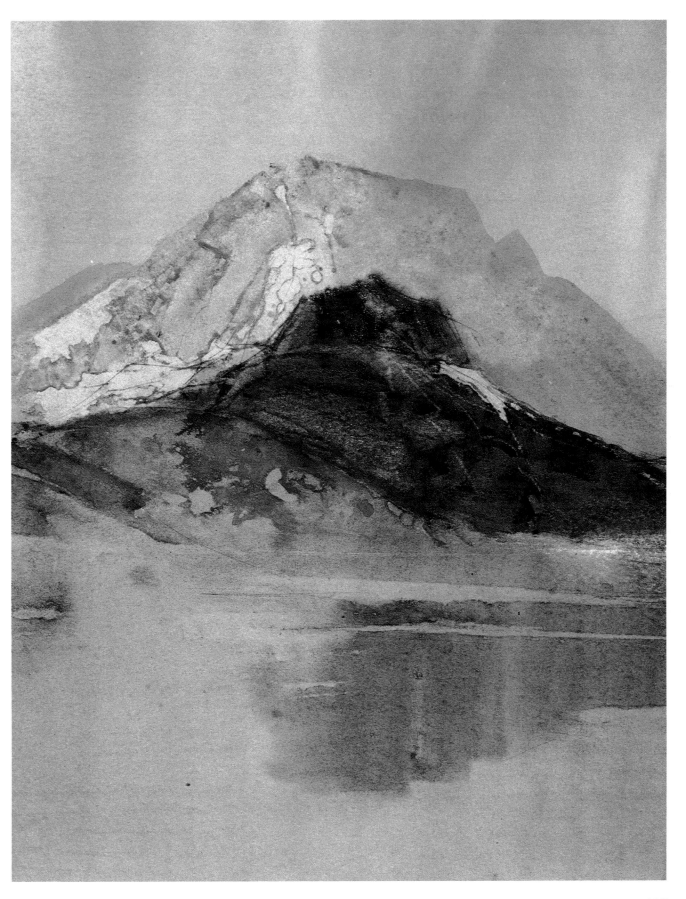

Conclusion

In the foreword I said that this book is something of a personal project, to restate the essential elements of watercolour painting and to use them to make traditional translucent watercolour paintings.

I have aimed to show the essential watercolour processes; washes of colour, adding and lifting colour. These techniques are the starting points that have to be mastered and from which personal attitudes and interpretations will develop. Because the medium is mobile and fluid, even basic brush techniques are capable of individual personality. No brush stroke can be exactly repeated, and each mark is unique.

It is the mobility of the medium which makes the traditional 'wet in wet' process so exciting and this I have tried to convey in the paintings made for the book. In showing these paintings I have also tried to suggest ways of looking at the world around us. By constantly looking and enquiring our minds become stimulated and enriched. Familiar objects take on special, personal meanings which influence our paintings and, hopefully, bring about that unique bit of magic.

It is important to look at other painters' work—at work that appeals to you, and at work that does not appeal. See how other painters have dealt with problems and situations you yourself have experienced. You need to see as many examples of paintings as you possibly can.

The important aim, always, is to try to decide what appeals to you especially. It is only by making such searching enquiry that you will produce sincere work. Try to find your own goal—painting *is* a selfish process, and you must work for yourself and do what you wish to do. Never paint with the object of selling—to do so is to paint for somebody else. Paint for yourself, so that the activity is always one of research, enquiry and adventure.

Index